RICHARD RASKIN

GUSTAVE COURBET'S « LES CASSEURS DE PIERRES »

ASPECTS OF A MAJOR WORK OF ART

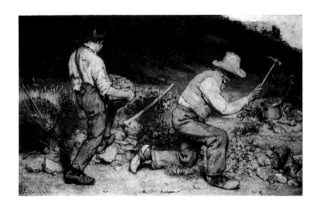

AARHUS UNIVERSITY PRESS

Aarhus University Press
Aarhus University
DK-8000 Aarhus C
Tlf. 06 19 70 33

The publication of this book was supported by a grant from Århus University's Research Foundation.

Other books by the author:

TIL RAOUL WALLENBERG. Samlerens Forlag, 1982. Co-edited with Aage Jørgensen.
THE FUNCTIONAL ANALYSIS OF ART. AN APPROACH TO THE SOCIAL AND PSYCHOLOGICAL FUNCTIONS OF LITERATURE,
 PAINTING AND FILM. Arkona, 1982/1983.
Claude Chabrol's QUE LA BÊTE MEURE. Fransklærerforeningens Bogudgivelser, 1985.
Louis Malle's LACOMBE LUCIEN. Fransklærerforeningens Bogudgivelser, 1986.
FILM TERMINOLOGY / TERMINOLOGIE DU CINÉMA. Aarhus University Press, 1986.
ELEMENTS OF PICTURE COMPOSITION. A DIGEST OF MAJOR CONTRIBUTIONS TO THE STUDY OF DESIGN IN THE VISUAL
 ARTS. Aarhus University Press, 1986.
COLOR. AN OUTLINE OF TERMS AND CONCEPTS. Aarhus University Press, 1986. Danish edition, 1987.
SOME PROCEDURES FOR SOUND EDITING ON VIDEOTAPE. Aarhus University Press, 1987.
NUIT ET BROUILLARD by Alain Resnais. ON THE MAKING, RECEPTION AND FUNCTIONS OF A MAJOR DOCUMENTARY
 FILM. Aarhus University Press, 1987.
Claude Goretta: LA DENTELLIÈRE - EN FILMBOG. Systime, 1988. In collaboration with Flemming Forsberg
 and Gerhard Boysen.

CONTENTS

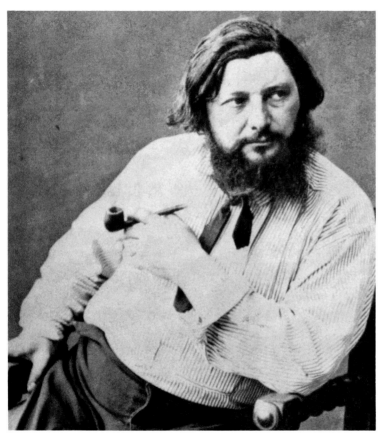
Photograph of Gustave Courbet by Thibouet.

— Pauvres casseurs de pierre, qui donc vous aurait compris, qui donc vous aurait peints, si M. Courbet ne vous avait pas aimés, et n'avait pas souvent heurté sa chope contre votre verre plein?

Le vin qu'il but avec vous, les enfants résignés du malheur, c'était le sang du peuple qui, lui passant au coeur, le réchauffait et l'exaltait.

E. Gros-Kost, COURBET. SOUVENIRS INTIMES (Paris: Derveaux, 1880), pp. 195-196.

INTRODUCTION

Although LES CASSEURS DE PIERRES is universally acknowledged as one of the most salient landmarks in 19th Century painting, it has been the object of remarkably little serious research. Routinely included in books and articles on Courbet, where it is dispatched in a passage ranging from a couple of paragraphs to several pages, the painting has been the sole focus of only one article until now.[1] A second article deals with this and one other picture at some length, but in so extravagantly far-fetched a manner that it almost verges on a leg-pull.[2] In view of the importance of the painting and the minimal attention it has received to date, a book on LES CASSEURS DE PIERRES is long overdue.

Unfortunately, the present whereabouts of the painting are unknown. In 1944, it was transferred for safe-keeping from the Dresden Gemäldegalerie to Wachau Castle, at a time when the museum's art treasures were parcelled out to depots in the general vicinity of Dresden. A number of commentators have stated that LES CASSEURS DE PIERRES was burned in 1945 during the fire-bombing of Dresden when a truck transporting 154 paintings from one depot to another was caught in the flames. When I contacted the Dresden museum to request further details, I was surprised to learn that: a) LES CASSEURS DE PIERRES was not among the 154 paintings lost on the ill-fated transport; b) the administration of the Staatliche Kunstsammlungen Dresden consider the painting to be missing, not destroyed; and c) "The one thing that is certain is that the Courbet was not burned on the

night of February 13/14 in Dresden, as is often stated in the literature."[3] It can therefore be hoped that the painting will surface again some day.

My observations regarding the composition of LES CASSEURS DE PIERRES are based on the best color reproduction available: a print issued by VEB E. A. Seemann in Leipzig, on the basis of a pre-war color photograph, and measuring 30 x 49.5 cm. It shows considerably more detail than is visible in any of the smaller reproductions. I have however deliberately refrained from commenting on color values for obvious reasons.

The first half of the present study is devoted to questions of composition, particularly with regard to major differences between the final version of the painting and the small oil sketch now at Winterthur. In comparing the preliminary with the final work, I have drawn on concepts developed by such theoreticians as Wölfflin, Gaffron and Arnheim, as well as on the work of experimentalists in the field of visual perception. I hope to show, in the process, that prevailing views regarding the degree of Courbet's concern with composition, should be seriously reconsidered.

The remainder of the study deals with the social significance of LES CASSEURS DE PIERRES, considered by some to be the first socialist painting. Courbet's own comments will be discussed, as well as a full spectrum of views proposed by admirers and opponents. In considering these views, I will try to place LES CASSEURS DE PIERRES in a historical perspective, especially with regard to the workers' insurrection of June 1848. Attention will also be given to several strategies commentators have used in an attempt to marginalize the political significance of the painting, as well as to idealist objections to LES CASSEURS DE PIERRES

and to the realist esthetic it embodies. Finally, six ways of interpreting the face-lessness of the stonebreakers will be briefly sketched.

This book deals exclusively with LES CASSEURS DE PIERRES. Readers interested in an overview of Courbet's entire production or in the painter's biography, should look elsewhere; many excellent works, listed in the bibliography at the end of this study, might be consulted by readers looking for a more general treatment of Courbet.

Immediately following this introduction, the reader will find a chronological 'fact sheet,' briefly outlining what is known of the history of the painting. And in an appendix, I will try to settle a curious question regarding the size of LES CASSEURS DE PIERRES.

Richard Raskin
Århus, Denmark
September 1988

NOTES

[1] Michael Nungesser, "Die Steinklopfer," in COURBET UND DEUTSCHLAND (Köln: DuMont, 1978), pp. 560-573.

[2] Michael Fried, "Painter into Painting: On Courbet's 'After Dinner at Ornans' and 'Stonebreakers,'" CRITICAL INQUIRY 8 (Summer 1982), pp. 619-649. A number of Fried's postulates will be discussed below.

[3] I am indebted to Hans-Jörg Göpfert, Wiss. Mitarbeiter, Staatliche Kunstsammlungen Dresden, for his most informative letters of May 25 and July 4, 1988.

CHRONOLOGY

November 1849

While on his way to the Château de Saint-Denis to paint a landscape, Courbet notices two stonebreakers working on the road near Maisières: an old man - 'le père Gagey' - and a boy. Struck by the poverty they embody, Courbet decides to paint them and arranges for them to pose for him at his studio the following day. After painting some preliminary oil sketches and a new posing session in which the old stonebreaker faces right (rather than left as in the initial session), Courbet executes the large final painting in which the figures are almost life-size. This is the first picture Courbet paints in the new studio his father has placed at his disposition for the painting of large canvases, in the house owned by his father at Ornans.

Spring and Summer 1850

Addressing himself directly to the public, Courbet organizes private exhibitions of several new works - including LES CASSEURS DE PIERRES and L'ENTERREMENT À ORNANS - at the seminary chapel at Ornans in March or April; at the concert room of Les Halles at Besançon in May; and at Dijon in July. Privately organized one-man shows of this type - circumventing official institutional channels and bringing works of art to local communities - are virtually unheard of at this time.

Repeated delays in the opening of the Salon of 1850, due to political conflicts, result in an opening so late in the year (December 1850) that it is declared the joint Salon of both 1850 and 1851. Since Courbet won a medal for his VIOLONCELLISTE at the Salon of 1848, all nine works he now submits to the Salon are automatically accepted: LES CASSEURS DE PIERRES (entry no. 663), L'ENTERREMENT À ORNANS, PAYSANS DE FLAGEY RETOURNANT DE LA FOIRE, VUES ET RUINES DU CHÂTEAU DE SCEY-EN-VARAIS,

BORDS DE LA LOUE SUR LE CHEMIN DE MAISIÈRES, L'HOMME À LA PIPE (a self-portrait), L'APÔTRE JEAN JOURNET, and portraits of Hector Berlioz and Francis Wey. LES CASSEURS DE PIERRES as well as L'ENTERREMENT À ORNANS are singled out for particular attention by critics and visitors to the Salon. While many reactions are strongly hostile in response to what is experienced as a challenge to prevailing artistic and political values, some visitors - among them Jules Vallès - find a new breath of life in LES CASSEURS DE PIERRES.

Autumn 1851 LES CASSEURS DE PIERRES makes a strong impression on Belgian artists (Charles de Groux among others) and critics, when it is exhibited - along with LE VIOLONCELLISTE - at the Exposition de Bruxelles.

Spring 1855 LES CASSEURS DE PIERRES (entry no. 2801) is among the eleven paintings by Courbet which are accepted by the jury for the combined Salon of 1855 and Exposition Universelle (L'ENTERREMENT and L'ATELIER DU PEINTRE having been rejected). For this reason, LES CASSEURS DE PIERRES is not among the works Courbet exhibits at his 'Pavillon du Réalisme,' which includes the two rejected canvases and forty-one other paintings.

1865 LES CASSEURS DE PIERRES is one of the paintings singled out for particular attention by P. J. Proudhon in his book, DU PRINCIPE DE L'ART ET DE SA DESTINATION SOCIALE. Proudhon suggests that LES CASSEURS DE PIERRES is the first truly socialist painting.

1867 LES CASSEURS DE PIERRES is among the 136 works exhibited at Courbet's private show at the Rond Point du Pont de l'Alma. It is purchased by Laurent Richard for 16,000 (one commentator writes 20,000) francs.

1869	LES CASSEURS DE PIERRES is exhibited at Munich where it is said to enjoy "un formidable succès."
1871	According to some sources (including Aragon and R. Fernier), LES CASSEURS DE PIERRES is purchased in 1871 by M. Binant, who will own the painting until 1904, when it is sold to the Dresden museum. However, catalogues of the May 1882 and 1929 exhibitions at the École des Beaux-Arts and Petit Palais, respectively, as well as a letter Courbet wrote in 1869, suggest that the painting belonged to a M. Georges Petit. (See p. 113 below for specific references.)
April-May 1876	"Exposition des CASSEURS DE PIERRES" at 70, rue Rochechouart in Paris.
May 1882	LES CASSEURS DE PIERRES is entry no. 4 in the "Exposition des oeuvres de Gustave Courbet" held at the École des Beaux-Arts in Paris.
1889	At the Exposition Universelle in Paris, LES CASSEURS DE PIERRES is entry no. 201.
20 April 1904	On the occasion of the sale of the Binant collection, LES CASSEURS DE PIERRES is purchased for the Staatliche Kunstsammlungen at Dresden for the sum of 50,000 francs by a Herr von Seidlitz.
May-June 1929	LES CASSEURS DE PIERRES is entry no. 36 at the "Exposition Gustave Courbet" at the Petit Palais.
December 1935 – March 1936	LES CASSEURS DE PIERRES is entry no. 21 in the Courbet exhibition at the Zurich Kunsthalle.

1944	At a time when art treasures belonging to the Staatliche Kunstsammlungen Dresden are being secured in 45 depots in the vicinity as the Russian army advances from the east, LES CASSEURS DE PIERRES is moved to the Wachau Castle for safe-keeping.
1945	All traces of the painting are lost. Although it is routinely stated in the literature on Courbet that LES CASSEURS DE PIERRES was destroyed when a truck carrying 154 paintings from one depot to another, was caught in the fire-bombing of Dresden on the night of February 13/14, the Staatliche Kunstsammlungen Dresden have informed me that LES CASSEURS DE PIERRES was not a part of that transport, and is now considered to be missing, not destroyed.

PART ONE

COMPOSITION : FROM OIL SKETCH TO FINAL PAINTING

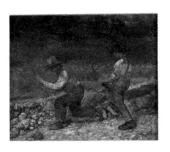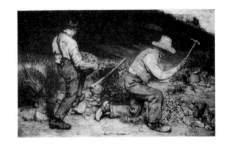

LES CASSEURS DE PIERRES, 1849. Oil
on canvas, 56 x 65 cm. Sammlung
Oskar Reinhart, "Am Römerholz,"
Winterthur.

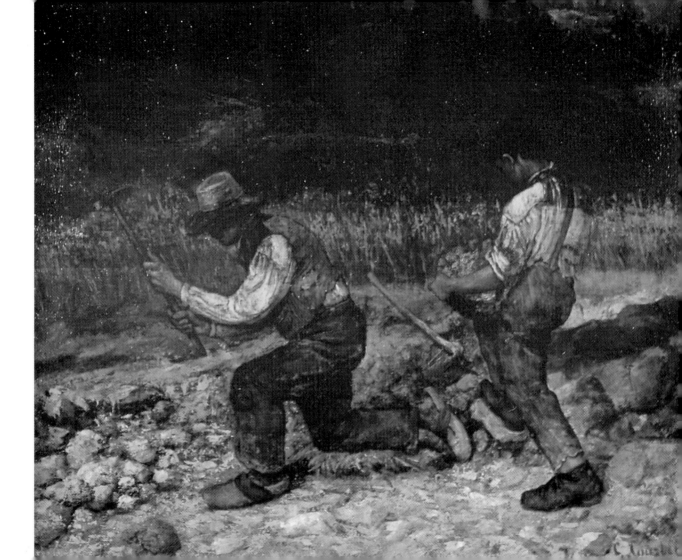

FRIED'S POSTULATES ON THE FIGURE REVERSAL

In the small, preliminary oil sketch Courbet made of the two stonebreakers (re-produced on p. 15 above), the figures face from right to left, with the old man situated on the left side of the picture. When proceeding to paint the final, full-sized picture, however, Courbet reversed the direction in which the figures face and placed the old man on the right side of the canvas.

Only one commentator has dealt with the question as to <u>why</u> Courbet chose to reverse the figures in this way. In a lengthy article devoted to both L'APRES DÎNER A ORNANS and LES CASSEURS DE PIERRES, Michael Fried points out that the final painting was not only much larger than the oil sketch, but also

> departed from it significantly by reversing the direction of the composition so that the figures faced from left to right. Other changes made between sketch and painting include widening the interval between the two figures, reducing the propor-tion of the canvas given over to the landscape (the upper sixth of the original composition was eliminated), emphasizing the material reality of the figures and in general distinguishing them more sharply from their setting, and introducing the wicker basket and long handle to the left of the young man and the lunch pail

and spoon to the right of the old one. In addition, seemingly a minor point, the artist's signature was shifted from the lower right to the lower left (op. cit., pp. 636-637).

Fried's main contention in this article is that Courbet "appears time and again to have sought to transpose himself as if bodily into the painting on which he was working" - not only in the self-portraits of the 1840's but also in L'APRES-DÎNER A ORNANS and LES CASSEURS DE PIERRES (p. 620). Fried further suggests that Courbet's paintings sometimes contain "displaced or metaphorical representations of the painter-beholder's right and left hands as those hands were actively engaged in the task of painting" (p. 640). What this means with respect to the issue of the reversed figures in LES CASSEURS DE PIERRES had best be read in Fried's own words:

> ...the figures of the old stonebreaker and his young counterpart may be seen as representing the painter-beholder's right and left hands respectively; the one wielding a shafted implement that bears a distant analogy to a paintbrush or palette knife, the other supporting a roundish object that might be likened to the (admittedly much lighter) burden of a palette. Viewed in these terms, the decision to reverse the composition of the oil sketch turns out to have been crucial, the preliminary right-to-left arrangement tending to run the two figures together and in general containing no more than the germ of the metaphorical representation of the painter-beholder at work that receives so full and precise development in the final painting (pp. 641-642).

Fried apparently means that in the final painting, the metaphorical representation of the painter's right hand (the old man) is on the right, and the metaphor for Courbet's left hand (the boy) is on the left. Presumably, Fried sees this more appropriate alignment of right and left as a motivating factor in Courbet's decision to reverse the composition.

A second postulate of Fried's concerning the reversal of the figures, is that the boy and old man embody in their respective postures the letters "G" and "C" of the painter's signature. In the final painting - according to Fried - the letter-figures are turned the right way and placed in the proper reading order:

...it requires no vast effort of imagination to read the figure of the young man resting the pannier of stones on his knee as a fleshing out of the backward-leaning but forward bending letter "G" and the figure of the old man about to strike a blow with his hammer as an elaboration of the slightly top-heavy letter "C" as both appear in the lower left-hand corner of the painting. (The possibility of such a reading goes back to the decision to reverse the composition of the preliminary sketch and thereby to accept the directional logic of the signature as basic to the painting as a whole.) (p. 643)

Enlargement of the "G" and "C" (partly corrected for distortion) as they appear in Courbet's signature on LES CASSEURS DE PIERRES.

Unfortunately, Fried provides no diagram showing exactly how the letters "G" and "C" are embodied respectively by the boy and old man; only a detail of the Courbet

signature is given, and the rest is left up to the reader's imagination - as though the letter-figure correspondence were so obvious that any concrete demonstration would be superfluous. I, for one, have considerable difficulty in finding the letters in the two stonebreakers, and remain not only unconvinced but also somewhat astonished by both of Fried's sensationally ingenious postulates, which are among the best examples of specious reasoning I have ever encountered in a scholarly publication.

The principal reasons for which Courbet reversed the figures when proceeding from oil sketch to final painting, concern fundamental improvements in the com-position of the picture, as I hope to show in the following pages.

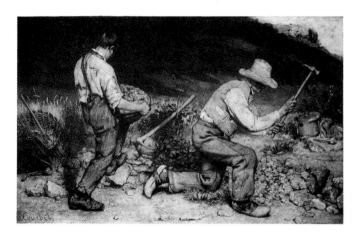

THE GLANCE-CURVE

According to Mercedes Gaffron, whose article on "Right and Left in Pictures"[1] remains one of the most interesting commentaries on that subject, our glance tends to enter any given picture at the left foreground, penetrating into the depth of the picture space, then turning toward the right (p. 317). Gaffron's figures A and B illustrate what she calls the "glance-curve" as seen in perspective and from above, respectively:

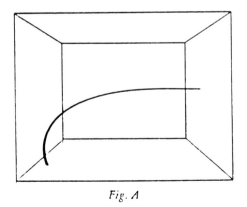

Fig. A

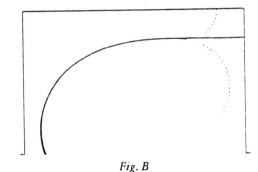

Fig. B

Having compared a particular painting with its mirror image in some detail, Gaffron summarizes and generalizes her conclusions as follows:

> All the emotional effects are explained by the location of our apparent standpoint in the left foreground of the picture space. This gives a completely different psychological value to the right and left sides of a picture. It explains why we have the feeling that the left side is "our side." We not only feel that the objects represented here are nearer to us, but also that they have greater importance for us. People represented here belong to our side in the figurative sense of the term, in contrast to the people on the right side. A person standing in the left foreground with his back turned toward us arouses a decided feeling of identification with ourselves, because his position comes nearest to the one we assume as spectator. For the same reason we feel that a person looking out of the picture from the left foreground is directly opposed to us. He may by his position not only block our glance, but also consume too much of our interest, easily throwing the picture off balance... (p. 321)

Gaffron's claim that the psychological value a figure has, depends on its location on the right or left side of a picture, should be taken with a grain of salt - even though Rudolf Arnheim concurs that the left side of the picture field is experienced as the "home base," "the main center with which the viewer primarily identifies,"[2] and some experimental evidence suggests a "left field bias."[3] The theoretician who first called serious attention to the right-left issue in the context of art - Heinrich Wölfflin - considered the <u>right</u> side of a picture to be the more

decisive one in determining the viewer's experience of a picture's overall mood,[4] and some experimental evidence indicates that pictures are generally found to be more esthetically pleasing when their most important content is situated on the right.[5]

Whatever differences of opinion may prevail regarding other aspects of these problems, one overriding issue on which both theoreticians and experimentalists agree, is that pictures _are_ generally 'read' from left to right in Western cultures (the opposite apparently being the case in cultures where the written word is read from right to left[6]). However, the rightward sweeping glance-curve does not seem to correspond to observable eye movements - the sequence of fixations and displacements that has come to be known as the 'scanpath.' In this connection, what Gaffron wrote in 1950 remains true today: "The relationship of the glance-curve to physical eye movements has still to be determined" (p. 317).[7]

My own understanding of the glance-curve concept is that in Western culture, the average (right-handed) viewer of a picture:

a) experiences his/her psychological engagement in or penetration of the picture space as located at the _left_ - ideally, as Gaffron stated, through a figure whose back is partially turned toward the viewer, or through some other device facilitating entry;

b) grasps the basic logic of a picture through successive shifts of attention, progressing either more or less smoothly from left to right - with the result that figures facing rightward tend to facilitate that flow, while

leftward facing figures seem to resist it;[8]

and c) experiences as the culmination of the picture's logic and final focus into or through which his/her attention flows, a point located at the right of the picture space and designed to facilitate a sense of psychological disengagement from that space.

Furthermore, instead of generalizing as to which portion of the visual field holds the most privileged content - the left according to Gaffron and Arnheim, the right according to Wölfflin - I would suggest that the left is privileged initially, as point of entry;[9] the middle or middle-right as central and perhaps most lingering focus;[10] and the right in the final moment, as completing the perceptual event and providing a point of disengagement. In other words, all three portions of the glance-curve are equally important - or rather, each in turn is the most important of the three, depending on where the viewer is momentarily located in the temporal cycle of the perceptual event.

That cycle can of course be 'replayed' by the viewer any number of times, until a sense of saturation is reached. And it is also clear that the viewer can choose to stray from the main path in order to explore portions of the painting lying outside the glance-curve, and may also deliberately scan the painting in a direction opposite to that of the glance-curve.[11] Individual differences, as well as variations in successive viewings by the same subject who freely directs his/her experience of a painting, can certainly be allowed for, without in any way discrediting the basic model which deals with general tendencies in the experience

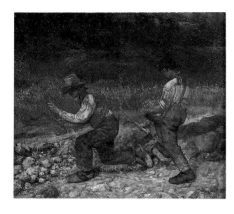

and design of pictures.

Returning now to LES CASSEURS DE PIERRES, we can make several observations concerning differences between the oil sketch and final painting, in the light of the glance-curve concept outlined above.

With the oil sketch, our glance enters the picture space at the figure of the old man, whose right-to-left orientation momentarily counteracts the rightward turn of the glance-curve. When that rightward movement is begun, it again encounters a figure whose position offers resistance to that flow: the boy, through whose body the glance-curve is turned obliquely back toward the right edge of the picture surface, in a direction diametrically opposed to that in which the boy is facing. Had these been portraits, resisting the glance-flow would have been more appropriate; but these virtually faceless figures are not portraits, and their resistance to the rightward flow of the glance-curve serves no particular purpose.

Furthermore, according to a principle proposed by Wölfflin (note 4), three diagonal vectors - the hammer-shaft in the old man's hands, the axis of his torso, and the shaft of the implement between the two figures (the line of that implement prolongued by the boy's right foot and lower left leg) - are all perceived as descending and tend to pull the glance-curve downward as it crosses the picture space from left to right. This downward pull counteracts the upward-leaning diagonal of the boy's torso and strap. All this, along with the absence of any compositional pathway leading from the boy to the upper right corner of the painting,

result in an almost negligible status for the patch of sky. If the sky fulfilled a merely decorative function, its marginality would not constitute a serious flaw. But in view of the symbolic meaning Courbet himself ascribed to the patch of sky (to be discussed shortly), its marginal status in the oil sketch is inappropriate.

In the final version, on the other hand, the boy's position at the left side of the painting, with his back turned partially toward us as he faces inward and toward the right, makes of him a perfect point of entry for the glance-curve, which turns with him and flows onward toward the old man. He in turn is positioned in a way that facilitates the rightward flow of the glance-curve. And here, the three diagonal vectors which were perceived as descending in the oil sketch, are now ascending and serve to pull the glance-curve upward as it crosses

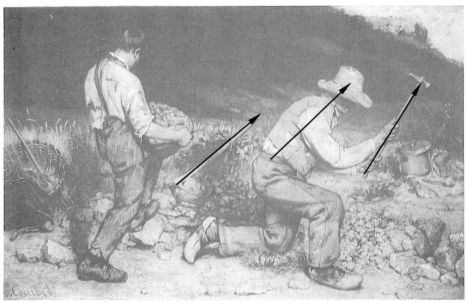

25

the picture space from left to right. Consequently, the patch of sky which was by-passed by the glance-curve in the oil sketch, becomes the culminating focus for our attention in the final painting, where it serves as a perfect exit or point of disengagement for the glance-curve.

Another point, which is secondary but still worth making, is that in the final painting, the order in which the figures encounter our glance - first the boy and then the old man - corresponds to the sequence in their life-cycle, as Courbet himself described it: "Hélas! dans cet état, c'est ainsi qu'on commence, c'est ainsi qu'on finit."[12]

In any event, in view of the positioning of the figures and major vectors in the final painting, it is almost as though the composition were designed to ease our glance as smoothly as possible into the picture space through the boy, then to accommodate its uninterrupted flow from left to right, to the old man - the central focus in the picture - and finally onward to the penetrable sky in the upper right corner, where the glance-curve exits from the picture as smoothly as it had entered. In these respects, the more 'fluent'[13] composition of the final painting is esthetically more pleasing than that of the oil sketch, which resists the flow of the glance-curve at every point.

STRUCTURAL REGULARITIES AND COHERENCE

Although no compositional features interfere in any way with the upward pull of the three vectors already discussed, there is - in the final version of the painting - a subtle visual counterpoint to those vectors, in the form of numerous downward sloping parallel diagonals which are roughly (though not entirely) perpendicular to them. These diagonals are concentrated on the right side of the painting, where there are also, of course, some diagonals sloping at other angles and therefore not a part of this contrapuntal alignment.

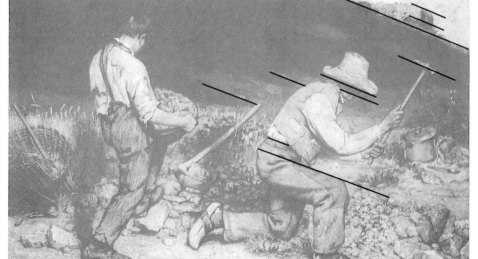

Other geometric regularities on the right side of the painting include: a) the fact that if the diagonal line of the hammer-shaft were extended, it would intersect with the corner angle of the painting after crossing - with the same nearly perpendicular angle - the slopes

of the hammer-head and of the hillside; b) the perpendicular relationship between the old man's lower left and lower right legs, which in turn are parallel to the painting's nearby bottom and right edges, respectively; c) the parallel relationship of the uppermost surface of the rocky crest to the nearby upper edge of the painting, and the equally parallel relationship of the vertical edges of the crest's shaded facade, to the nearby right edge of the painting.

In THE POWER OF THE CENTER, Rudolf Arnheim distinguishes between two systems of spatial organization: one characterized by parallel and perpendicular relationships, a kind of 'Cartesian grid'; the other characterized by 'centric patterns,' 'converging radii,' "symmetrical structures... shaped around a central point, a central axis, or at least a central plane."[14] Arnheim suggests that in works of art, "the interaction between the two spatial systems generates formally the complexity of shape, color, and movement that our visual sense cherishes..." (p. x).

If we apply these concepts to LES CASSEURS DE PIERRES, we can note that the right side of the final painting is characterized by numerous parallel and perpendicular relationships, already mentioned above (though many of the structures in question have been rotated in relation to the frame, so that they come across as sets of diagonals). The left side of the painting is, however, predominantly radial in character: if the shafts of the two implements on either side of the boy

28

are projected downward, they cross at about the same point from which the line of the boy's body (extending upward along the back of his right leg and continuing along the strap on his back) also issues - the three lines radiating from a point near the boy's right ankle. And although it could, of course, be argued that the relationship between the projected lines of the two implements is roughly perpendicular, their approximate symmetry in relation to the boy and the location of the point at which they cross, give this structure a predominantly radial character.

In the context of this somewhat subtle structural differentiation between the

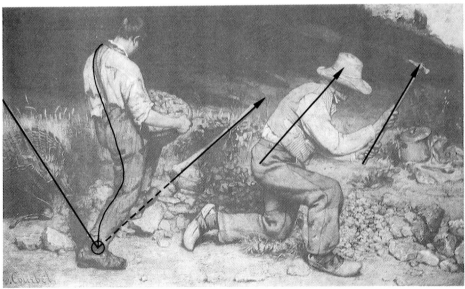

left and right sides of the painting, the implement situated between the boy and the old man plays a literally pivotal role in the composition, since it is simultaneously the right side of the radial structure in the left half of the painting, and the farthest to the left of the three nearly parallel vectors that dominate the right half of the canvas.

In this respect, the centrally located implement helps to bind together the two halves of the painting.

A second factor contributing to the coherence of the painting, is what might be called the 'arc of ovals' extending from the far left to the far right of the picture space in the final painting. This series of oval shapes, which progressively diminish in size, is doubly radial, since each individual shape is itself centric, and

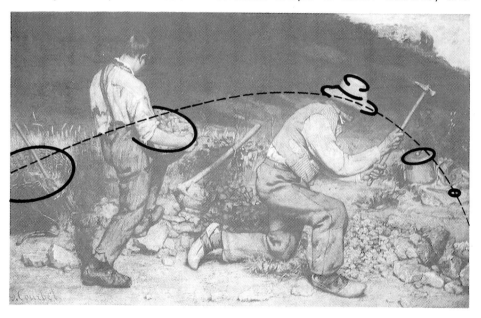

the configuration formed by these shapes collectively is also centric. This 'arc of ovals' - a variant of which Courbet used again in his CRIBLEUSES DE BLÉ - can be seen as a kind of literally overarching structure, the double roundedness of which provides a formal counterpoint to the right-angled and even to the radial patterns on the right and left, respectively.

Gustave Courbet, LES CRIBLEUSES DE BLÉ 1853-1854. Oil on canvas, 131 x 167 cm. Musée des Beaux-Arts, Nantes.

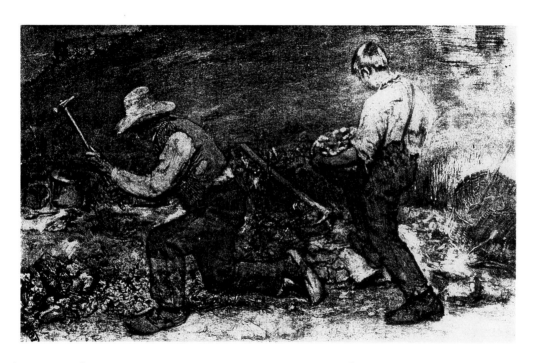

'Phototypie' of LES CASSEURS DE PIERRES in A. Estignard's COURBET. SA VIE, SES OEUVRES
(Besançon: Delagrange-Louys, 1906).

BALANCE

Although Rudolf Arnheim has suggested that the left side of a picture can better accommodate a heavy weight than can the right,[15] some experimental evidence has shown that viewers tend to find a composition more esthetically pleasing when the weightier and more important content is on the right (Levy, op. cit.). I believe that a comparison of the oil sketch and final version of LES CASSEURS DE PIERRES would favor the experimental evidence rather than Arnheim's claim.

In the oil sketch - at least, once you are accustomed to the final painting - the composition appears to be too heavy on the left. This is so, not only because the figure of the old man outweighs that of the boy, but also because the road they are working on seems to be tipped somewhat downward in the direction in which they are turned. Also contributing to a less stable composition is the fact that the two figures are less anchored in place by the frame, since there is a greater distance between them and the frame in the oil sketch.

In the final painting, on the other hand, a better balance is achieved by placing the heavier figure on the right, with a substantial counterweight on the left side, in the form of what Michael Nungesser called a "kompositorische Schwerpunktzone" created by the junctures on the left of projected prolongations of the implements and the axes of the two figures.[16] Furthermore, the horizontality of of the scene has been emphasized by making the road more level and the picture proportionally wider or less high; in addition, the closer framing of the figures

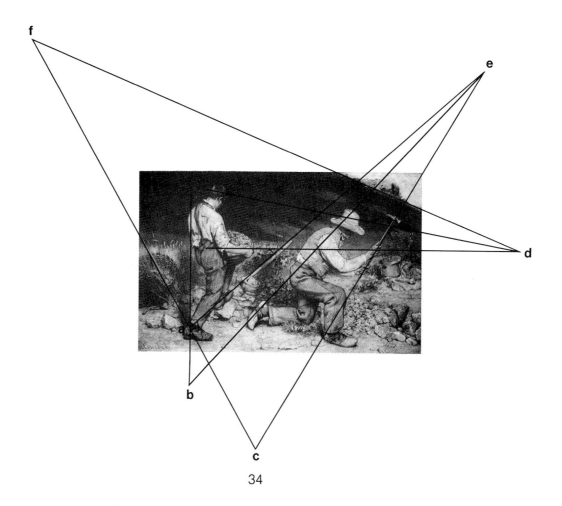

contributes to the stability of the picture. That the heavier figure is better accommodated on the right than on the left (at least when the figures face right and left respectively[17]), can be observed by looking at the mirror-image reversals that have occasionally appeared in the literature on Courbet (pp. 32 and 36). In these reversals, even with the more level road, wider format and closer framing, the picture still looks somewhat unstable or too heavy on the left.

While Nungesser's comments on the balance in LES CASSEURS DE PIERRES, mentioned above, are quite perceptive, they might be taken a step further. On the facing page, I have tried to represent graphically the major junctures to which Nungesser referred, as well as several others that might be seen as equally important.

A and B - and possibly C - are the points constituting what Nungesser referred to as the "kompositorische Schwerpunktzone" on the left, while D is the major counterweight on the right. Instead of considering the blue triangle of sky to be an additional counterweight, as Nungesser suggested, I propose in its place the juncture of projected prolongations of the axis of the old man's torso, the hammer in his hands, and the implement lying between him and the boy (E). An additional juncture on the left (F), where the projected prolongations of the implement to the boy's left and the sloping hillside meet, should also be taken into account. The balancing of these junctures, most of which are 'off-canvas,' in addition to the balancing of objects and figures depicted in the painting (plus the compositional weight of Courbet's signature), result in the exceptional equilibrium found in the final version of LES CASSEURS DE PIERRES.

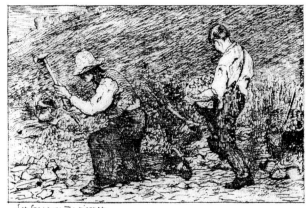

Les casseurs de pierres

Etching by A.-P. Martial in the Comte
H. d'Ideville's GUSTAVE COURBET. NOTES
ET DOCUMENTS SUR SA VIE ET SON OEUVRE
(Paris: Alcan Lévy, 1878).

ON COURBET AND COMPOSITION

As Lorenz Dittmann pointed out and illustrated with a number of quotations, Courbet's friends and enemies alike have generally agreed that his paintings lack composition.[18] To those statements to that effect which have already been assembled by Dittmann, the following might be added - beginning with one which is intended to make a virtue of the presumed lack of composition:

Courbet ne pense pas et il ne compose pas. Champfleury dira de ses paysages qu'ils ont "la qualité suprême de l'horreur de la composition." Il ne composera jamais, même dans ses périodes de la plus grande virtuosité, parce que la composition peut-être n'était pas son fort, ses grands tableaux le prouvent, surtout parce qu'il ne voulait pas. Composer c'est déjà transposer, commenter, tricher avec la vérité de l'instant, avec le fait brutal et nu, "la nature positive, immédiate," avec une réalité dont toute la force tient à son insignifiance même.[19]

Son absence radicale d'imagination, l'insurmontable difficulté qu'il éprouvait à composer un tableau, l'avaient engagé à créer ce que l'on a nommé le réalisme, c'est-à-dire la représentation exacte des choses de la nature, sans discernement, sans sélection, telles qu'elles s'offrent aux regards.[20]

Gustave Courbet, LA RENCONTRE or BONJOUR M. COURBET, 1854. Oil on canvas, 120 x 149 cm. Musée Fabre, Montpellier.

Mirror-image of LA RENCONTRE, used by Berger to illustrate his view that a Courbet painting can be reversed with no appreciable change or loss. "Courbet in his Century," GAZETTE DES BEAUX-ARTS 24 (1943), pp. 24-25.

However, the commentator who asserted most systematically that realism in general, and Courbet's realism in particular, involved a breakdown of composition, was Klaus Berger whose article on the subject[21] has been influential in the study of art history.

According to Berger, classical style is characterized by a strong compositional order, with a hierarchical structuring of accents and valuations. Modern realism, on the other hand, involves a "breaking up of the composition," "a loosening of the pictorial structure," a "parcelling up of the artistic composition into units" which are arranged at random - what he calls "the principle of diversified units," each of which has the same pictorial value in the new 'egalitarian' visual field. As a consequence of this breakdown of composition (compensated for by a new fullness of individual forms), a painting by Courbet can - according to Berger - be reversed without any appreciable change or loss. The example he uses is the well-known BONJOUR, MONSIEUR COURBET, and applying Wölfflin's technique of reproducing a picture along with its mirror-image,[22] Berger suggests that in the case of this painting, the original and mirror-image "look enough alike so that one hesitates before deciding which is which" - the opposite being the case for the classical paintings studied by Wölfflin, in which the reversed image produces an entirely different effect and lacks the 'enchantment' of the original (pp. 22-23).

It is almost as though Courbet's choice to reverse the figures when proceeding from the oil sketch to the final version of LES CASSEURS DE PIERRES, were undertaken to refute the validity of these assertions. The compositional improvements he made, on the basis of sound artistic instinct and experience, have been

discussed in relation to: a) the advantages gained by orienting the figures in a left-to-right direction, to facilitate the smoothest possible entry, flow and exit of the viewer's glance, and to make the sky a more integral part of the viewer's experience by means of vectors guiding the flow of attention in its path; b) the orchestration of relatively subtle visual counterpoints - including the interplay of radial and right-angled or parallel structure, and ensuring the coherence of the painting as a whole through such devices as the 'arc of ovals'; and c) managing the arrangement of weights and counterweights, as well as using a wider format, closer framing and a better 'stage' for his figures, in order to stabilize the composition in a perfectly balanced equilibrium.

At least in the case of LES CASSEURS DE PIERRES - and, I suspect, the same is true of other works as well - the assertion that Courbet lacked a sense of organic composition, and instead applied a kind of additive compositional principle,[23] or worked entirely without concern for compositional values, is indefensible.

AN ADDITIONAL CHANGE : CORRECTING AN APPARENT ERROR

It is not unheard of for painters to make - and to correct - errors concerning right and left. For example, Manet was warned by Baudelaire that he had placed the spear-wound on the wrong side of Jesus' torso in the painting, ANGES AU TOMBEAU DU CHRIST, about to be sent to the Salon of 1864: "A propos, il paraît que le coup de lance a été porté à droite. Il faudra donc que vous alliez changer la blessure de place. Vérifiez donc la chose dans les quatre évangélistes. Et prenez garde de prêter à rire aux malveillants." [24] Having already deposited the painting at the Palais de l'Industrie, Manet was unable to make the change before the exhibition but did so at a later time.

Curiously, in a water-color version painted sometime after Baudelaire's warn-ing, Manet deliberately placed the wound on the wrong side, but reversed the en-tire composition around it, "afin de réparer à demi sa trahison du texte évan-gélique." [25] Though this reverse-image water-color may have been intended as a basis for a subsequent engraving, when Manet finally got around to making that engraving, he apparently based it on the corrected oil painting, instead of the re-versed water-color, with the result that the wound was once again on the wrong side. [26]

An earlier painting by Manet, LE CHANTEUR ESPAGNOL, also called LE GUITARRERO (1860), posed a somewhat related problem. Normally the neck of a guitar is held in the player's left hand, while the strings are strummed or picked with the fingers of the right hand; in Manet's painting, the opposite is the

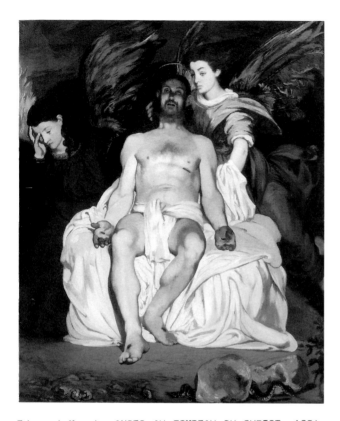

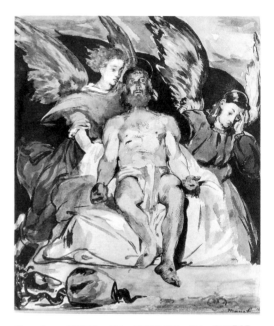

Manet, ANGES AU TOMBEAU DU CHRIST,
1864. Water-color, 32.3 x 27 cm. Musée
d'Orsay. Cliché des Musées Nationaux
- Paris.

Edouard Manet, ANGES AU TOMBEAU DU CHRIST, 1864.
Oil on canvas, 179.4 x 149.9 cm. Metropolitain Mu-
seum of Art, Bequest of Mrs. H.O. Havemeyer, 1929.
The H.O. Havemeyer Collection. (29.100.51)

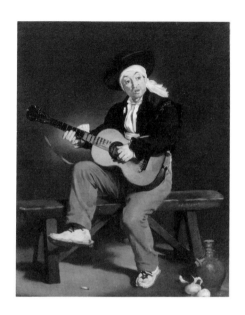

Manet, LE CHANTEUR ESPAGNOL or LE GUITARRERO, 1860. Oil on canvas, 147.3 x 114.3 cm. Metropolitain Museum of Art, Gift of William Church Osborn, 1949 (49.58.2)

case. As one commentator pointed out, Manet's model "was either left-handed or unable to hold a guitar. This shortcoming is remedied in a subsequent engraving in which the composition is reversed."27

In the oil sketch of LES CASSEURS DE PIERRES, the old man holds the long-shafted hammer with his <u>left</u> hand uppermost on the shaft. Normally, the <u>right</u> hand would be in that position - as can be seen on the photograph on p. 44: note how the 'sabotier' in the center of the picture has placed his hands on the shaft of the hammer he is swinging. That the same applies to the tools of a stonebreaker was confirmed by Aarhus stonecutter, Peter Sørensen, to whom I wish to express my appreciation.

It is known that Courbet had the old man - le père Gagey - return to his studio for an additional session in which the pose was changed, reportedly in order to improve the position of the model's <u>legs</u>. Here is Riat's account of both posing sessions:

43

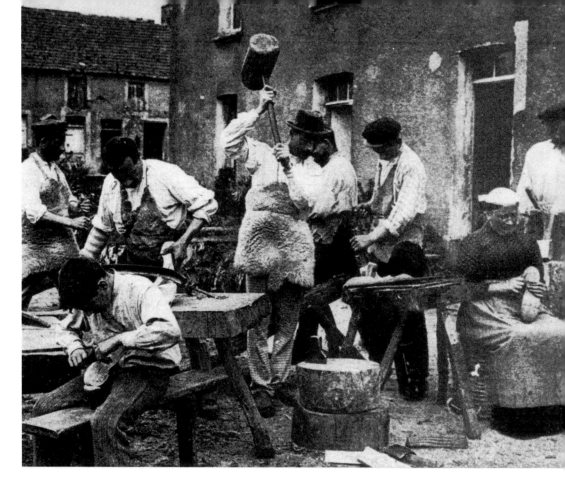

This is the central portion of a picture-postcard. Its caption reads: "LITTRY - Un groupe de Sabotiers des Petits-Carreaux près la forêt de Balleroy."

J. L. Charmet/Documentation Française.

Courbet fit poser séparément ses casseurs de pierres. Nous connaissons une belle étude du gamin, et une étude du vieillard, toutes deux en Suisse. Le vieux can-tonnier s'appelait Gagey. Il prit l'attitude du travail, avec son outil, le genou ployé contre terre. Après examen, Courbet s'avisa que la pose n'était pas bonne. Il s'en vint retrouver le père Gagey, pour le peindre en équilibre sur le genou gauche, préférable selon lui, au droit. "T'as raison, Gustave, dit le vieux, pla-cidement, les casseurs de pierres, faut que ca change souvent de genou."[28]

While it is undoubtedly true that Courbet had the old man kneel on the other knee in the final session, as Riat reports, the painter must also have instructed his model to face in the opposite direction, and to hold the shaft of the hammer with his right hand uppermost - thereby correcting what might otherwise have ap-peared to be an error on the artist's part.[29]

I am not arguing that Courbet reversed the direction in which his figures faced solely in order to correct the apparent error; if that had been his major concern, he could have left the composition as it was, and simply placed the old man's hands on the shaft of the hammer in the proper position. As already discussed in some detail, it was with respect to compositional values that Courbet reversed the figures in this painting. However, that reversal _also_ enabled him to correct the ap-parent error, and in so natural a manner that the change has not been noticed until now.

NOTES

[1] ART QUARTERLY 13 (1950), pp. 312-331.

[2] THE POWER OF THE CENTER (Berkeley: University of California Press, 1982), p. 38.

[3] T. M. Nielsen and G. MacDonald found that a significant majority of subjects who were asked to select titles for a series of pictures, chose titles corresponding to the content in the left foreground of the picture. "Lateral Organization, Perceived Depth and Title Preference in Pictures," PERCEPTUAL AND MOTOR SKILLS 33 (1971), pp. 983-986. A left bias was found in another context as well by Christopher Gilbert and Paul Bakan, who demostrated that our idea of what someone looks like is determined predominantly by the side of the face in the viewer's left visual field. "Visual Asymmetry in Perception of Faces," NEUROPSYCHOLOGIA 11 (1973), pp. 355-362.

[4] "Über das Rechts und Links im Bilde" (1928), in GEDANKEN ZUR KUNSTGESCHICHTE (Basel: Benno Schwabe, 1941), pp. 82-90. Wölfflin suggested in this article that because a picture is read from left to right, a diagonal with a right side higher than the left is perceived as ascending, and with a left side higher than the right as descending. This was also the first article I know of in which pictures were compared with their mirror images.

[5] Jerre Levy, "Lateral Dominance and Aesthetic Preference," NEUROPSYCHOLOGIA 14 (1976), pp. 431-445.

[6] Charles G. Gross and Marc H. Bornstein, "Left and Right in Science and Art," LEONARDO 11 (1978), p. 36. Henrik Bruun Sørensen, VERBAL OG VISUEL STRUKTUR. KINESISK KALLIGRAFI, POESI OG LANDSKABSMALERI. Unpublished thesis. Art Department, Århus University, 1986, p. 79.

[7] Gross and Bornstein (op. cit.), pp. 36-37 and Arnheim (op. cit.), pp. 37-38, also acknowledge the need to distinguish between the glance-curve and eye movements.

[8] A leftward facing figure is apparently most appropriate to portraiture, since there the face is intended to <u>hold</u> the viewer's attention, rather than transmit it onward toward the right. I. C. McManus and N. K. Humphrey have found that out of 1474 portraits painted in Western Europe between 1500 and the present, a majority face leftward. "Turning the Left Cheek," NATURE 243 (1973), p. 27. As Gross and Bornstein point out, "Leonardo da Vinci, perhaps the most famous left-handed artist, preferred to draw right-facing profiles" (op. cit., p. 35).

The same general principle applies to the direction of depicted movement in a painting: "Movement from left to right in a painting is easier and faster, while movement from right to left is slower and perceived as having to overcome resistance" (Gross and Bornstein, p. 36). The classic example of this view in the literature on the subject, is G. Schlosser's discussion of Breughel's PARABLE OF THE BLINDMEN. In the picture as Breughel painted it, the blind men - facing right and moving diagonally downward toward the right - seem to tumble into the ditch, while in a mirror-image reversal of the picture,

Schlosser suggested that the blind men - now facing left and moving down what appears to be a diagonally ascending slope - seem to be pressing their leader into the ditch. "Intorna alla lettura dei quadri," LA CRITICA 28 (January 1930), pp. 72-79; esp. p. 73. Gaffron (op. cit., p. 321) has also suggested that represented movement "has the character of an approach if it is directed from right to left, and of withdrawal if it is directed from left to right."

[9] Gross and Bornstein point out that "similar aesthetic vectors seem to operate in stage direction... as the curtain rises at the beginning of an act, the audience can be seen to look to the left front (op. cit., p. 36).

[10] In an article entitled "Left and Wrong in Adverts; Neuropsychological correlates of Aesthetic Preference," BRITISH JOURNAL OF PSYCHOLOGY 72 (1981), pp. 225-229, Andrew W. Ellis and Diane Miller wrote: "It may be purely a convention to 'read' a painting from left to right as we read a book and so preferring the important content on the left where we can move towards it and then let our

eyes rest there"(p. 226). The sentence presumably contains a misprint, since it would make considerably more sense if it read: "... and so preferring the important content on the right where we can move towards it and then let our eyes rest there." In any event, it would seem perfectly reasonable to suggest that it is the portion of the glance-curve situated between the points of entry and of disengagement that would normally allow for the most sustained attention - all other factors being equal.

[11] Boris Uspensky has suggested that even "in a series of pictures where the same figures participate in a left-to-right sequence - there is a much greater freedom (more than in other forms of art) in our temporal ordering of it. We may choose to read the sequence from left to right in the normal order; or we may reverse the sequence, reading backward from right to left (the same way that a film might be run backward); or we may choose any scene as our starting point and move at will in any direction, completely altering the temporal arrangement. This reordering of sequence is not possible in other arts (literature and film, for instance) where the time orientation is determined." What Uspensky concludes from this, however, overshoots his mark in my opinion: "We can conclude, then, that time is not an essential factor in the structure of pictorial art forms, and that the freedom we have observed is a consequence of its relative lack of importance." That there is a "normal order" or "temporal arrangement" from which the viewer may choose to depart, suggests that it is essential to take into account both a given temporal sequence built into the work(s) of art and the viewer's freedom. The quotes above are from A POETICS OF COMPOSITION (Berkeley: University of California Press, 1973), pp. 77-78.

[12] This sentence from a letter to Francis Wey, dated November 26, 1849, will be given in its full context on pp. 56-57 below.

[13] The very apt term, "fluent," was suggested by Dr. Lisbeth Stähelin, curator of the Oskar Reinhart Collection at Winterthur. In the same personal communication, Dr. Stähelin al-

so described the oil sketch as "stronger in mental expression" than the final work. Perhaps it is because the oil sketch offers resistance to the natural flow of the glance-curve, that it gains in a kind of intensity usually associated with portraiture, something of what it loses in purely compositional terms.

[14]Op. cit., pp. vii-x. I find the overall terms Arnheim ascribed to the two systems somewhat misleading: "parochial" for the system of right-angled relationships; and "cosmic" for the system characterized by radial centricity.

[15]ART AND VISUAL PERCEPTION (Berkeley and Los Angeles: University of California Press, 1969; orig. pub. 1954), p. 23; and THE POWER OF THE CENTER (op. cit.), p. 38.

[16]Op. cit., p. 563. Nungesser wrote: Gedachte Fluchtlinien, die Werkzeuge und Körperachsen verlängern, treffen sich in verschiedenen Schnittpunkten nahe des unteren Bildrandes. Diese kompositorische Schwerpunktzone bildet ein Gegengewicht zu dem blauen Dreieck des Himmels und den sich rechts ausserhalb des Bildes treffenden Fluchtlinien, die entlang der Umrisse des Kornfeldes, den Köpfen der Arbeitenden und dem von dunklen Schatten überlagerten, baumlosen Bergabhang laufen."

[17]It is possible that the direction in which a figure faces, in combination with its location on the left or right side of the picture space, can affect the apparent heaviness of the figure. For example, it is worth considering whether a figure on the left facing against the direction of the glance-curve, might seem to weigh more than it would if facing toward the right. As far as I can tell, this has not been considered to be a potential variable regarding apparent weight in either the theoretical or experimental literature on right and left in pictures.

[18]"Courbet und die Theorie des Realismus," Sonderdruck aus BEITRÄGE ZUR THEORIE DER KÜNSTE IM 19.JAHRHUNDERT. Frankfurt, 1971, pp. 215-239; cited passages at pp. 228-229.

[19] André Fermigier, COURBET (Geneva: Skira, 1971), pp. 23-24.

[20] Maxime du Camp, cited by Comte H. d'Ideville, GUSTAVE COURBET. NOTES ET DOCUMENTS SUR SA VIE ET SON OEUVRE (Paris: Alcan-Lévy, 1878), p. 68.

[21] "Courbet in his Century," GAZETTE DES BEAUX-ARTS 24 (July 1943), pp. 19-40.

[22] Op. cit. A brief summary of Wölfflin's essay, along with some of the examples he used, will be found in my ELEMENTS OF PICTURE COMPOSITION (Århus University Press, 1986), pp. 37-40.

[23] See Dittmann, op. cit., pp. 228-229.

[24] Pierre Courthion, MANET RACONTÉ PAR LUI-MÊME ET PAR SES AMIS (Geneva: Pierre Cailler, 1953), vol. 1, p. 110.

[25] A. Tabarant, MANET ET SES OEUVRES (Paris: Gallimard, 1947), p. 81.

[26] Kurt Martin, EDOUARD MANET. AQUARELLE UND PASTELLE (Basel: Phoebus-Verlag, 1958), notes on plate 8.

[27] John Richardson, MANET (London & New York: Phaidon, 1969), p. 83. Tabarant (op. cit., p. 41) wrote of this painting: "...Manet, étourdiment, fit de ce guitariste un gaucher, et quand il s'en aperçut il était trop tard."

[28] Georges Riat, GUSTAVE COURBET, PEINTRE (Paris: Floury, 1906), p. 47.

[29] An amusing passage in Gros-Kost's COURBET. SOUVENIRS INTIMES (Paris: Devreaux, 1880), shows that the painter's father was constantly finding fault with his son's work, chiding and correcting him for what he considered to be errors or shortcomings in the pictures: "Vois donc ça. C'est un rocher? Et ça. C'est un arbre? Tu devrais être honteux. Ton gazon est absurde. Mes boeufs n'en voudraient certainement pas. Quant à ton eau, pourquoi en parler? Ca ne ressemble à rien. Tes cailloux n'ont pas de sens commun. Ton ciel est comme

un parapluie..." (pp. 42-43). With this passage in mind, it would not be difficult to imagine Courbet chided by his father for having painted the hands of the old stone-breaker incorrectly. And whether the apparent error was due to Courbet's having inadvertently posed his model incorrectly, or to the possible left-handedness of the Père Gagey, this could have been one situation in which it seemed more appropriate to bow to the criticism, rather than to shrug it off.

Gustave Courbet, LE CASSEUR DE PIERRES, 1849. Oil on canvas, 45 x 54.5 cm. Now in a private Swiss collection, according to Courthion (1985, p. 77), it was previously in a private collection in Italy (Durbé, 1969, p. 56; Nungesser, 1978, p. 561).

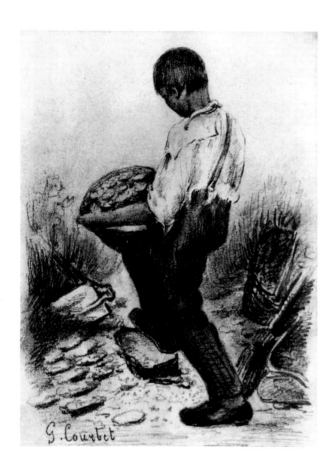

Courbet, JEUNE CASSEUR DE PIERRES. Drawing, 31.5 x 23.9 cm. Musée Courbet, Ornans, n° dessin RF/52

The dating of this drawing is somewhat problematic. In the catalogue of the exhibition, COURBET DANS LES COLLECTIONS PRIVÉES EN FRANCE, held at the Galerie Aubry in Paris in May-June 1966, it is stated that this drawing was "vraisemblablement exécuté en vue de sa reproduction par F. Gillot dans L'AUTOGRAPHE AU SALON ET DANS LES ATELIERS (1865) et dans L'AUTOGRAPHE (1872)." In "Courbet Zeichnungen" (COURBET UND DEUTSCHLAND, op. cit.), p. 355, Marget Stuffmann concurs and adds that there is some question as to whether this 1865 drawing really is the work of Courbet. However, neither commentator provides any evidence in support of the view that this drawing was not made by Courbet in 1849, when the boy actually posed for the painter.

The Musée Courbet lists 1865 as the date of this drawing; however, I know of no reason for excluding the possibility that the drawing could have been made in 1849.

52

JEUNE CASSEUR DE PIERRES, lithograph. I have been unable to find an indication of its date. Though this print is nearly identical to the drawing on the facing page, the figure Courbet drew on the lithographic stone was, of course, turned toward the right - as in the final painting.

The lithograph is reproduced in R. Broby-Johansen's book, DAGENS DONT GENNEM ÅRTUSINDE. HISTORIEN OM ARBEJDSBILLEDET (Copenhagen: Fremad, 1969), p. 208.

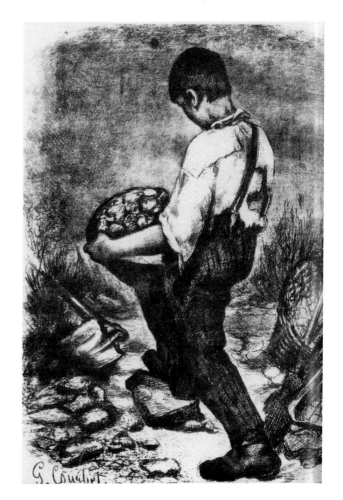

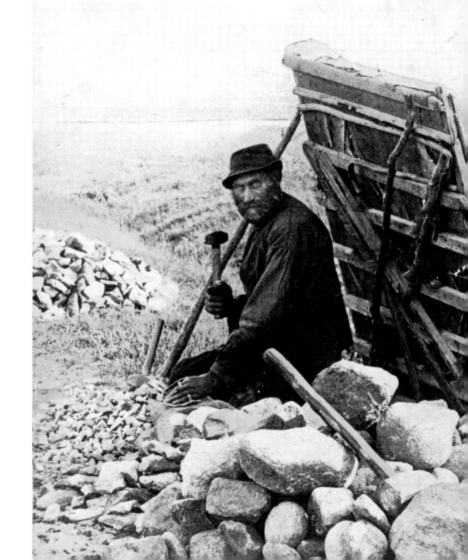

Danish stonebreaker, Rasmus
Klemmensen, Hadbjerg, c. 1900;
from Jørgen Sørensen's "HER
KOMMER FRA DYBET" - Landprole-
tariatet 1880-1915. Copenhagen:
Gyldendal, 1976.

ON THE SOCIAL SIGNIFICANCE OF "LES CASSEURS DE PIERRES"

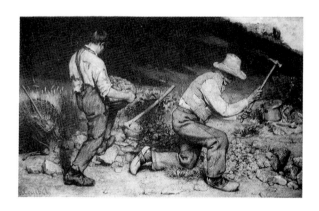

COURBET'S STATEMENTS ON THE PAINTING

It is always interesting to know how an artist perceives his or her own work, and in the case of LES CASSEURS DE PIERRES, the records we have of Courbet's views on the painting are particularly important, since the issue of his initial intention has frequently been evoked by commentators seeking to minimize the political significance of the painting - a subject to be dealt with shortly.

The earliest document we have in which Courbet described LES CASSEURS DE PIERRES, is a letter dated November 29, 1849, presumably written soon after the painting had been completed, though there is a chance the work was still in progress:

...J'avais pris notre voiture, j'allais au Château de Saint-Denis faire un paysage; proche de Maisières, je m'arrête pour considérer deux hommes cassant des pierres sur la route. Il est rare de rencontrer l'expression la plus complète de la misère, aussi sur-le-champ m'advint-il un tableau. Je leur donne rendez-vous pour le lendemain dans mon atelier, et depuis ce temps j'ai fait mon tableau. Il est de la même grandeur que la SOIRÉE À ORNANS. Voulez-vous que je vous en fasse la description? ...Là est un vieillard de soixante et dix ans, courbé sur son travail, la masse en l'air, les chairs hâlées par le soleil, sa tête à l'ombre d'un chapeau de paille; son pantalon de rude étoffe est tout rapiécé; puis dans ses sabots fêlés, des bas qui furent bleus laissent voir les talons. Ici, c'est un jeune homme à la tête poussiéreuse, au teint bis; la chemise dégoûtante et en lambeaux lui

laissent voir les flancs et les bras; une bretelle en cuir retient les restes d'un pantalon, et les souliers de cuir boueux rient tristement de bien des côtés. Le vieillard est à genoux, le jeune homme derrière lui, debout, portant avec énergie un panier de pierres cassées. Hélas! dans cet état, c'est ainsi qu'on commence, c'est ainsi qu'on finit! Par-ci par-là est dispersé leur attirail: une hotte, un brancard, un fossoir, une marmite de campagne, etc. Tout cela se passe au grand soleil, en pleine campagne, au bord du fossé d'une route; le paysage remplit la toile. Oui, M. Peisse, il faut encanailler l'art! Il y a trop longtemps que les peintres, mes contemporains, font de l'art à l'idée et d'après des cartons...[1]

It is noteworthy that what had struck Courbet when he first saw the two stone-breakers at work on the road, was the degree to which they embodied poverty; in his eyes, they were "l'expression la plus complète de la misère." In this connection, he devoted a relatively large portion of his letter to their coarse and damaged clothing - the major visual signs of their hardship. And curiously, a number of grammatical constructs cast that clothing in an active role, as the subject of a verb: "des bas... laissent voir," "la chemise lui laisse voir...," "une bretelle de cuir retient...," "les souliers de cuir boueux rient tristement..." I will return to this in a moment, after citing a subsequent letter by Courbet.

Also noteworthy is the fact that Courbet perceived the boy and old man as trapped by their work or station in life, in a wretched, cyclical process from which there was no hope of escape ("Hélas! dans cet état, c'est ainsi qu'on commence, c'est ainsi qu'on finit"). Finally, a mock aside is addressed to a Salon reviewer ("Oui, M. Peisse") who, like many others, had objected to the 'vulgarization' of

57

art brought about by people like Courbet - a charge which Courbet, in typical fashion, aggressively turned into a virtue in a brief counter-attack against those artists whose refinement consisted in painting, not what they saw around them in the real world, but those nonexisting figures which the cultural elite expected them to portray ("l'art à l'idée").

In a second letter written in the Spring of 1850, much of the earlier description was repeated, along with some important new elements:

D'abord, c'est un tableau de Casseurs de pierres qui se compose de deux personnages très à plaindre; l'un est un vieillard, vieille machine raidie par le service et l'âge; la tête basanée et recouverte d'un chapeau de paille noire; par la poussière et la pluie. Ses bras qui paraissent à ressort, sont vêtus d'une chemise de grosse toile; puis, dans son gilet à raies rouges se voit une tabatière en corne cerclée de cuivre; à son genou posé sur une torche de paille, son pantalon de droguet qui se tiendrait debout tout seul à une large pièce, ses bas bleus usés laissent voir ses talons dans ses sabots fêlés. Celui qui est derrière lui est une jeune homme d'une quinzaine d'années ayant la teigne; des lambeaux de toile sale lui servent de chemise et laissent voir ses bras et ses flancs; son pantalon est retenu par une bretelle en cuir, et il a aux pieds les vieux souliers de son père qui depuis bien longtemps rient par bien des côtés. Par-ci, par-là les outils de leur travail sont épars sur le terrain, une hotte, un brancard (pioche), un fossou (fossoir), une marmite de campagne dans laquelle se porte la soupe de midi; puis un morceau de pain noir sur une besace.

Tout cela se passe au grand soleil, au bord du fossé d'une route. Ces personnages se détachent sur le revers vert d'une grande montagne qui remplit la toile

et où court l'ombre des nuages; seulement, dans le coin à droite la montagne qui penche laisse voir un peu de ciel bleu.

Je n'ai rien inventé, cher ami, chaque jour allant me promener, je voyais ces personnages. D'ailleurs, dans cet était, c'est ainsi qu'on finit. Les vignerons, les cultivateurs, que ce tableau séduit beaucoup, prétendent que j'en ferais cent que je n'en ferais pas un plus vrai.[2]

Among the most interesting additions in this second letter, is an explicit reference to the machine-like quality of the old man's body; he is now a "vieille machine raidie," with arms which "paraissent à ressorts." At the same time, there are again articles of clothing and other inert objects serving as the subjects of verbs: "son pantalon de droguet qui se tiendrait debout tout seul," "ses bas bleus usés laissent voir...," "des lambeaux de toile sale lui servent de chemise et laissent voir...," "les vieux souliers... qui rient par bien des côtés," "une grande montagne qui remplit la toile où court l'ombre des nuages," "la montagne qui penche laisse voir..." These two factors taken together - the reduction of a human being to the status of a machine, and the grammatical elevation of inert objects to the status of active agents - form a combination reminiscent of what we think of today as a Marxist concept, such as Lucien Goldmann's notion that the impact of capitalist economics produced within the 19th and 20th Century European novel a "transfert progressif du coefficient de réalité de l'individu à l'objet inert," "(un) transfert des fonctions actives des hommes aux objets."[3] In Courbet's day, as will soon be shown, a strikingly similar concept was maintained, often by culturally conservative idealist commentators, deploring what they saw as the new dehumanization of art.

Another addition in the second letter is Courbet's description of the background, including a reference to the small patch of blue sky at the upper right corner. According to several sources, the very smallness of that patch was significant for Courbet. Here is Riat's account (op. cit., p. 75):

> Dans un coin du tableau, au-dessus de cette scène lamentable, à droite des roches noires et lugubres, comme contraste, (Courbet) peignit un coin de ciel avec ce bleu de cobalt qu'il affectionnait pour cet usage, et qui équivaut à une signature, soit qu'il l'étendit sans voile, soit qu'il le fît transparaître parmi le feuillage des arbres: 'Pauvres gens! disait-il, j'ai voulu résumer leur vie dans l'angle de ce cadre; n'est-ce pas qu'ils ne voient jamais qu'un petit coin du ciel![4]

In the context of Courbet's own statements, the sky represents those <u>worldly</u> comforts and pleasures of which the stonebreakers enjoy so few. Commentators have, however, generally seen the sky in LES CASSEURS DE PIERRES in more transcendent terms, in comparing Courbet's painting to Millet's LES GLANEUSES with its open sky. Thus for some, the tiny patch of blue in the picture of the stonebreakers "implies that there exists for these workers no compensating heavenly justice, no divine being who might justify the earthly hell."[5] And in a similar Courbet-Millet comparison, Linda Nochlin wrote that "Millet's composition implies something beyond the mere fact of specific peasants performing a routine task, and conveys a comforting suggestion of the religious and moral beauty of labor in general. This sense of 'beyondness'... is conveyed by the formal configuration of the painting; the grandeur of the panorama which stretches out in the background, the reiteration of the bent forms of the three women in the haystacks which are the products of their humble labor, the hazy indications of productive

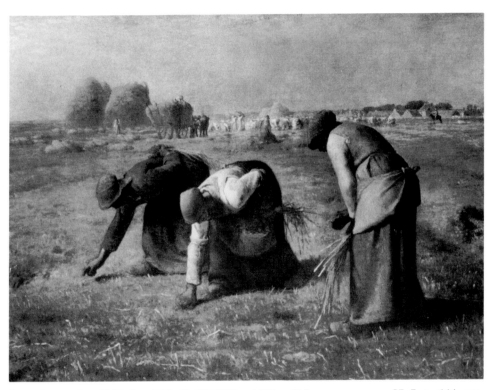

Jean-François Millet, LES GLANEUSES, 1857. Oil on canvas, 83.5 x 111 cm. Musée d'Orsay, Paris. Cliché des Musées Nationaux - Paris.

Jean-François Millet, L'ANGÉLUS, 1857-1859. Oil on canvas, 55.5 x 66 cm.
Musée d'Orsay, Paris. Cliché des Musées Nationaux - Paris.

human activity near the horizon - all of this carries the spectator beyond the realm of immediate fact to that of transcendent value... But Courbet's STONE-BREAKERS, on the contrary, implies nothing in formal terms beyond the mere fact of the physical existence of the two workers and their existence as painted elements on the canvas."[6]

While these views are most interesting, I must admit that I find little in LES GLANEUSES to suggest a transcendent dimension - though another nearly contemporary work by Millet, L'ANGELUS, does so in a perfectly obvious manner. In both Millet paintings, the amount of sky is about the same; but its meaning is shaped in large measure by the explicit thematic content of the picture. For this reason, I am somewhat skeptical of those readings of LES CASSEURS DE PIERRES which interpret the smallness of the patch of sky in terms of transcendence. If there is no transcendent dimension in Courbet's painting - and on that issue I am in full agreement - it is not because the sky is small, but because no thematic cue is present to evoke a transcendent dimension.

There is, for example, even less sky in Tassaert's UNE FAMILLE MALHEUR-EUSE (p. 64) than in LES CASSEURS DE PIERRES; and there is no sky at all in Isidor Pils' LA MORT D'UNE SOEUR DE CHARITÉ (p. 65). In other words, what generally determines whether or not a transcendent dimension is present in a picture, is the presence or absence of thematic cues, rather than formal or quantitative factors.

Returning now to the subject originally at hand - Courbet's statements on LES CASSEURS DE PIERRES - I would suggest that Courbet's own worldly view

←

Octave Tassaert, UNE FAMILLE MALHEUREUSE, also
called LE SUICIDE, 1849. Exhibited at the Salon
of 1850-1851 (that is, the same Salon in which
LES CASSEURS DE PIERRES was exhibited). Musée
d'Orsay, Paris. Cliché des Musées Nationaux
- Paris.

→

Isidore Pils, LA MORT D'UNE SOEUR DE CHARITÉ,
1850. Musée d'Orsay, Paris. Cliché des Musées
Nationaux - Paris.

of the sky be regarded as the most dependable basis for decoding whatever symbolic significance the sky may have in this painting.

<div align="center">

*

* *

</div>

While Courbet's letters on LES CASSEURS DE PIERRES and his reported comment on the sky in the painting, were from 1849-1850, a conversation Courbet had many years later (in March 1866) with his friend, the Comte d'Ideville, contains an important retrospective comment on the painting. In the interval, Courbet had become progressively more outspoken on political issues, and - from the time LES CASSEURS DE PIERRES made its impact - he had acquired a reputation as a socialist painter (as will soon be discussed). This development would culminate in his prominent role in the Paris Commune, as president of the Commission des Beaux-Arts. As might be expected, Courbet was increasingly subject to charges that his paintings were subversive and contained hidden political symbolism. Thus Courbet jokingly told the Comte d'Ideville in March, 1866, that his (Courbet's) enemies in the cultural establishment - ils, as he called them - would probably find his new painting, LA REMISE DES CHEVREUILS, harmless enough, "à moins qu'ils n'y voient une société secrète de chevreuils qui s'assemblent pour proclamer la République." [7] In Ideville's account of the same conversation, we also have a record of Courbet's reply to the suggestion that LES CASSEURS DE PIERRES expresses pity rather than protest. Ideville wrote:

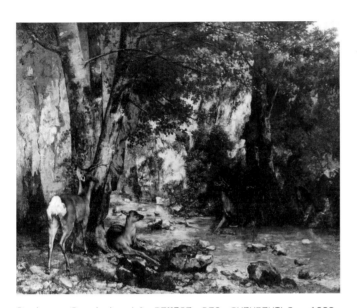

Gustave Courbet, LA REMISE DES CHEVREUILS, 1866.
Oil on canvas, 1.73 x 2.07 m. Musée d'Orsay, Paris.
Cliché des Musées Nationaux - Paris.

...Puis me retournant vers le mur où se détachait la fameuse toile des CASSEURS DE PIERRES: "Avez-vous, par exemple, lui dis-je, voulu faire de ces deux hommes courbés sous l'inexorable loi du travail, une protestation sociale? J'y vois, moi, tout au contraire, un poème de douce résignation et c'est une impression de pitié, qu'ils me font ressentir. - Mais cette pitié, répondit fort adroitement Courbet, elle résulte d'une injustice, et c'est en cela que, sans le vouloir, mais simplement, en faisant ce que j'ai vu, j'ai soulevé ce qu'ils appellent la question sociale" (ibid.).

In summing up Courbet's views on LES CASSEURS DE PIERRES, we can conclude that: 1) at the time the painting was first conceived, Courbet had been struck by the deprivation and hardship visibly suffered by the stonebreakers he portrayed; and 2) according to Courbet himself, the painting expresses not only pity but also an implicit protest against injustice.

— Pourquoi donc, papa, qu'on appelle ça de la peinture
socialiste?
— Parbleu! parce qu'au lieu d'être de la peinture riche,
c'est de la pauvre peinture!...

Cham, LE CHARIVARI, 1851. Reprinted
in Charles Léger, COURBET SELON LES
CARICATURES ET LES IMAGES (Paris: P.
Rosenberg, n.d.), p. 18.

Les *Casseurs de pierres*, remarquable toile... de **pantalons.**

Cham, REVUE COMIQUE DU SALON DE 1851. Reprinted
in Michael Nungesser's article (op. cit.),
p. 565.

THE FIRST SOCIALIST PAINTING? A SURVEY OF OPINIONS

While no categorical statement on this score would be appropriate, it is quite possible that LES CASSEURS DE PIERRES was the first painting to be publicly called 'socialist' in France. Even before a reviewer of the 1850 Salon submitted his manuscript to the REVUE DES DEUX MONDES, he could write of the latest manifestations of Courbet's esthetic, currently at the exhibition: "J'ai entendu dire que c'était là de la peinture socialiste."[8] In an 1851 caricature of LES CASSEURS DE PIERRES by Cham (on the facing page), reference was made to the presumably widespread circulation of the word 'socialist' in connection with the painting. And when Courbet was accused of being a socialist painter in an article in LE MESSAGER, he replied in a letter of November 19, 1851, that he was "non seulement socialiste, mais bien encore démocrate et républicain, en un mot partisan de toute la Révolution, et, par dessus tout, réaliste, c'est-à-dire ami sincère de la vraie vérité."[9] Here, Courbet willingly assumed the designation 'socialist,' though he took pains to embed it in a broader political and artistic context.

Other contemporary reactions point essentially in the same direction, though in a more diffuse manner - perhaps more expressive of class-consciousness than of a specifically political concern. Some ridiculed what was seen in the painting as unworthy of pictorial representation - particularly the trappings of rural labor and poverty, with much hilarity focused on the clothing worn by the two stonebreakers (pp. 68, 70). And a most revealing comment was apparently scrawled in the complaints book by a visitor to the Exposition Universelle of 1855: "On prie M. Courbet de vouloir bien faire raccommoder la chemise et laver les pieds à ses

EXPOSITION DE PEINTURE EN 1852.

M. Courbet ayant fait école, on ne trouvera en 1852, en fait de peintures, rien que des tableaux représentant des paysans.

Cham, LE CHARIVARI, 7 April 1851. Reprinted in Léger (op. cit.), p. 14.

Les Casseurs de pierre.

M. Courbet ayant observé que les peintres ses confrères avaient eu jusqu'alors la coutume de mettre les jambes dans les culottes qu'ils avaient à peindre, a cru devoir s'affranchir de cette routine. — Un pareil trait de génie est au-dessus de tout éloge.

Cham, LE CHARIVARI, 1851. Reprinted in Léger (op. cit.), p. 14.

70

Drawing by Daumier. Reprinted in Charles Léger, COURBET (Paris: Crès, 1929), p. 57.

Grands admirateurs des tableaux de M. Courbet.

casseurs de pierre. - Un homme propre et délicat" (Clark, op. cit., p. 190). Even Daumier, whom I would prefer to remember as a champion of the underdog in such pictures as his "Rue Transnonain," couldn't resist making fun of Courbet by suggesting that the painter's admirers were grotesquely unrefined and uncultured people, whose station in the social hierarchy made them unfit even to visit a Salon.

15 'Democritisation de l'art'

Cham, "La démocratisation de l'art," L'ILLUSTRATION, 21 July 1855.
Reprinted in Léger, COURBET SELON LES CARICATURES ET LES IMAGES
(Paris: P. Rosenberg, n.d.), p. 29.

By and large, Courbet's work was a democratic challenge to elitist culture, since his canvases implicitly affirmed that no one and nothing is unworthy of full-scale representation in a painting. Even Courbet's relation to his public can be seen in terms of democratization. Who else had thought of circumventing established channels as he did in the Spring and Summer of 1850, when he took the initiative to organize special showings of LES CASSEURS DE PIERRES and UN ENTERREMENT A ORNANS at Ornans, Besançon and Dijon, bringing these paintings directly to the public?

Courbet's 'démocratisation de l'art' would probably have been somewhat threatening to the cultural establishment in France under any circumstances. But coming as it did in the wake of the 'June Days' of 1848, it was undoubtedly experienced as an even greater threat than it would otherwise have been. A thumbnail sketch of the events of June - especially with regard to the national workshops - will help to clarify this point.

According to a standard history of the period, the national workshops, intended to alleviate widespread unemployment,

> had been established at the demand of the Parisian mob shortly after the provisional government assumed control in February (1848), but neither a consistent plan nor a well-considered philosophy was evolved to direct this revolutionary institution. Presumably it was the brain child of Louis Blanc, but neither he nor any of the socialists had anything to do with its organization. Marie, minister of the interior, and Thomas, a young engineer who was made director, were responsible for planning the whole undertaking. Marie was hostile to the idea, and wanted nothing more than to demonstrate its impracticability; Thomas saw the

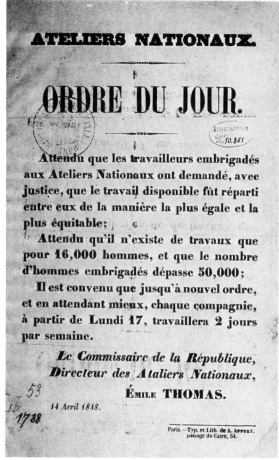

ATELIERS NATIONAUX.

ORDRE DU JOUR.

Attendu que les travailleurs embrigadés aux Ateliers Nationaux ont demandé, avec justice, que le travail disponible fût réparti entre eux de la manière la plus égale et la plus équitable;

Attendu qu'il n'existe de travaux que pour **16,000** hommes, et que le nombre d'hommes embrigadés dépasse **50,000**;

Il est convenu que jusqu'à nouvel ordre, et en attendant mieux, chaque compagnie, à partir de Lundi 17, travaillera 2 jours par semaine.

Le Commissaire de la République,
Directeur des Ateliers Nationaux,
ÉMILE **THOMAS.**

14 Avril 1848.

Paris.—Typ. et Lith. de A. APPERT, passage du Caire, 54.

Bibliothèque Nationale, Paris.

problem almost entirely as a question of organization. The result was that a mammouth, complicated machine was erected to administer the workshops, but little or no effort was made to secure effective plans, useful projects, or even proper tools. The armies enrolled in this revolutionary organization planted trees, fixed roads, dug ditches, filled up the ditches, and loafed. Very little was accomplished that had any great value to French society.[10]

As the ranks filled at a dizzying pace, increasing from about 6,100 in March to 36,000 in mid April, the government was unable or at least unwilling to bear the colossal expense. "It soon proved impossible to give every man work for every day, and a system was evolved whereby the enrollees received part pay for no work, and full pay only a few days a week" (ibid.). As the workers grew more resentful of cutbacks in the program, liberals in the government grew more bitter that the national workshops existed at all, especially when large numbers of men enrolled in the workshops participated in

74

(13 JUIN.)
RÉPUBLIQUE FRANÇAISE.
Liberté, Égalité, Fraternité.

MINISTÈRE DES TRAVAUX PUBLICS.

AUX TRAVAILLEURS
DES
ATELIERS NATIONAUX.

LE DIRECTEUR DES ATELIERS NATIONAUX,

Vu la loi sur les attroupements décrétée par l'Assemblée nationale le 7 du présent mois;
Vu la proclamation publiée par la Commission du Pouvoir exécutif lors de la promulgation de cette loi,

ARRÊTE :

Sera rayé des rôles des Ateliers nationaux tout Citoyen qui, étant attaché à ces Ateliers à un titre quelconque, aura fait partie d'un attroupement dans l'un des cas prévus et punis par la loi.

CITOYENS,

Déjà vous avez expulsé beaucoup de ceux qui n'avaient pas le droit de figurer au milieu de vous. La belle journée du 7 juin vous a vus fidèles à la cause de l'Ordre, inséparable de la cause de la République. La France entière sait aujourd'hui quel admirable spectacle vous avez présenté pendant ce recensement accompli en quelques heures, avec votre aide, avec votre concours empressé. Nos ennemis prédisaient le désordre; vous les avez noblement démentis.

D'une voix unanime vous avez réclamé des travaux, des travaux sérieux et productifs. L'Assemblée nationale et le Gouvernement viennent de vous en préparer; ils vous en donneront tous les jours de nouveaux. Bientôt chacun de vous pourra retourner aux travaux de son état.

Continuons donc l'œuvre que nous avons commencée. Que tout fauteur de désordre soit banni de nos rangs. Ne faisons entendre que le cri de

VIVE LA RÉPUBLIQUE!

Tout autre cri serait un attentat contre la souveraineté du Peuple.

Paris, le 12 juin 1848.

L'Ingénieur des Ponts et Chaussées Directeur des Ateliers nationaux,
Léon LALANNE.

VU ET APPROUVÉ :

Le Ministre des Travaux publics,
TRÉLAT.

IMPRIMERIE NATIONALE. — Juin 1848.

Bibliothèque Nationale, Paris.

a demonstration on May 15, and 'invaded' the Palais Bourbon where the Assembly was in session. De Tocqueville, a deputy in the Assembly at the time, described the growing crisis in French society in the following terms:

I found in the capital a hundred thousand armed working men formed into regiments, dying with hunger, but their minds crammed with vain theories and visionary hopes. I saw society cut in two - those who possessed nothing, united in greed; those who possessed something, united in common terror. There were no bonds of sympathy between these two great sections; everywhere the idea of an inevitable and immediate struggle seemed to be at hand (ibid., p. 207; no source given).

On June 21, the government abolished the national workshops and decreed that unmarried workers of military age were to join the army, "and told the others that employment on roads

in the provinces would be available to them" (ibid., p. 208). This sparked what began as a demonstration, with Parisian crowds chanting "On ne partira pas!" and ended as an armed insurrection that was crushed after four days of street-fighting - the first large-scale battle in which working people and representatives of the liberal bourgeoisie found themselves on opposite sides of the barricades.

With these events in mind, it is easier to understand why LES CASSEURS DE PIERRES and the esthetic it embodied, were perceived in political terms, when the memory of the June insurrection was still fresh.

Two commentators saw a direct connection between the crushing of the workers' insurrection, and the "frémissement d'indignation et de colère" inspired by LES CASSEURS DE PIERRES at the Salon of 1850. Castagnary wrote:

> Quoi! On avait dissous les ateliers nationaux, on avait vaincu le prolétariat dans les rues de Paris... et voilà que la "vile multitude", chassée de la politique, reparaissait dans la peinture! Que signifiait une telle audace? D'où sortaient ces paysans, ces casseurs de pierres, ces affamés et ces déguenillés, qu'on voyait pour la première fois s'avancer silencieux entre les divinités nues de la Grèce et les gentilshommes à panache du Moyen âge?...[11]

And Théodore Duret proposed essentially the same explanation in terms that were equally strong:

> On était alors en pleine réaction politique, on traquait par le pays ce qu'on appelait les rouges, les socialistes, les partageux et il semblait, en voyant les hommes du peuple apparaître dans l'audace de leurs traits exacts, que c'était

toute cette classe poursuivie au dehors, qui venait envahir brutale et menaçante
le domaine de l'art...[12]

And others have seen in LES CASSEURS DE PIERRES an even more specific allusion. For Linda Nochlin, the painting could be seen as bearing a "hidden reference to the discredited attempts of the National Workshops to provide employment for the proletariat, and hence could be interpreted as a 'socialist' subject" (op. cit., p. 146). And according to Sidney Finkelstein, "Courbet gave his art a true morality and social content, as in his STONEBREAKERS, in which he portrayed the miserable jobs given out to the unemployed workers by the 'republic' of 1848-1849."[13]

However, the very fact that laborers were represented on canvas by Courbet on such a large scale - they were practically life-size - was in itself a threat to the elite's sense of hierarchy, as Champfleury suggested:

M. Courbet est un factieux pour avoir représenté de bonne foi des bourgeois, des paysans, des femmes de village de grandeur naturelle. Ç'a été là le premier point. On ne veut pas admettre qu'un casseur de pierre vaut un prince: la noblesse se gendarme de ce qu'il est accordé tant de mètres de toile à des gens du peuple; seuls les souverains ont le droit d'être peints en pied, avec leurs décorations, leurs broderies et leurs physionomies officielles...[14]

It would have been different if Courbet had built into the staging of the scene some sign that his stonebreakers were humbly submissive to established social or

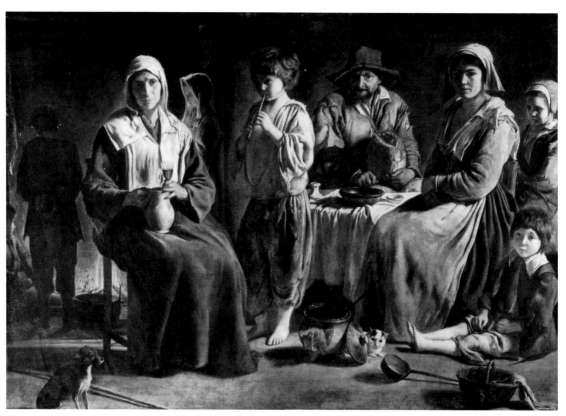

Le Nain, FAMILLE DE PAYSANS DANS UN INTÉRIEUR, 1648. Musée du Louvre. Cliché des Musées Nationaux - Paris.

religious codes. No one could find Millet's peasants threatening. And although the clothing of the poor in LA MORT D'UNE SOEUR DE CHARITÉ (p. 65 above) is just as tattered as the stonebreakers' attire, no one would perceive the disenfranchised in Pils' painting as either dangerous or out of place in a work of art, since their poverty is thoroughly embedded in a posture of religious devotion. The same applies, to some extent, to the mother in Tassaert's UNE FAMILLE MALHEUR-EUSE (p. 64 above).

Courbet's sin was not in realistically portraying the laboring classes in a work of art - Le Nain had done that 200 years earlier. Courbet's sin consisted in realistically portraying working people: a) <u>after June 1848</u>, when memories of the workers' insurrection and its bloody aftermath were still fresh; and b) <u>without politically neutralizing the subject by embedding it in an overriding, religious matrix</u>, portrayed in entirely traditional terms.

Courbet's old stonebreaker is hardly brandishing a red banner. Yet Max Buchon - Courbet's close friend and collaborator - found it fitting to write of the old man, in the notice for Courbet's exhibition at Dijon in the summer of 1850: "... cet homme, avec son âge, avec son rude labeur, avec sa misère et sa douce physionomie de vieillard, cet homme n'est pas encore le dernier mot de la détresse humaine. Pour peu que le pauvre diable s'avise à tourner au rouge, il peut être jalousé, dénoncé, expulsé, destitué. Demandez plutôt à M. le préfet."[15] It was in this same notice that Buchon described the grave-digger in Courbet's UN ENTERREMENT A ORNANS as the old stonebreaker's avenger:

Au fond, cet homme, ce fossoyeur, n'accuse rien de méchant dans sa robuste carrure. Lui seul même est à genoux dans cette immense réunion, et cependant, voyez!

Gustave Courbet, UN ENTERREMENT À ORNANS, 1849–1850. Oil on canvas, 3.15 x 6.68 m. Musée d'Orsay, Paris. Cliché des Musées Nationaux - Paris.

lui seul se rengorge, lui seul commande...

Et pourtant, faut-il le dire? à travers l'oppression vague où sa contemplation vous jette, on en revient involontairement, par idée de compensation sans doute, à notre pauvre casseur de pierres, dont ce fossoyeur-ci pourrait bien n'être, dans la pensée du peintre, que l'antithèse psychologique, le contre-poids; je dirais presque le vengeur (ibid., p. 164).

For the young Jules Vallès, whose subsequent novels and journalism probably constitute the very summit of socialist writing in France at the time, the political significance of LES CASSEURS DE PIERRES was unmistakable:

C'était, je crois, en 1850. Nous nous promenions, quelques amis et moi (le plus vieux pouvait bien avoir dix-huit ans), à travers les galeries de l'exposition. Tout d'un coup, nous nous arrêtâmes en face d'une toile qui, sur le livret, s'appelait LES CASSEURS DE PIERRES, et qui était signée en lettres rouges: G. Courbet.

Notre émotion fut profonde.

Nous étions tous des enthousiastes. C'était l'époque où fermentaient les têtes! Nous avions au fond de nos coeurs le respect de tout ce qui était souffrant ou vaincu, et nous demandions à l'art nouveau de servir lui aussi au triomphe de la justice et de la vérité.

Ce tableau teinté de gris avec ses deux hommes aux mains calleuses, au cou hâlé, était comme un miroir où se reflétait la vie terne et pénible des pauvres. La raideur gauche des personnages servait encore à l'illusion; et l'inhabileté ou le

Gustave Courbet, JULES VALLÈS, 1861.
Oil on canvas, 26.5 x 21.5 m. Musée
Carnavalet, Paris.

génie du peintre avait, dans un geste, indiqué l'immo-
bilité fatale à laquelle est condamnée sous un ciel in-
grat toute la race des mercenaires.[16]

However, in an article Vallès wrote more than
thirty years after his first meeting with LES
CASSEURS DE PIERRES, his enthusiasm for
the specifically artistic qualities of the paint-
ing had diminished considerably. He now wrote:
"Je crois que LES CASSEURS DE PIERRES ne
peuvent guère inspirer l'admiration que comme
première poignée de main donnée au travail
pénible. Mais si le coup de baïonnette dans la
tradition fut hardi, le coup de pinceau paraît
presque sec et gris aujourd'hui."[17]

Curiously, in this later article written over
a decade after the crushing defeat of the
Paris Commune, Vallès contrasted - by means
of a figurative parallel - the stonebreakers'
hammering of stones with the Communards'
canon-fire: "La toile de Courbet date du temps
où il n'y avait pas eu d'éclairs de triomphe
- si courts qu'ils aient été - au-dessus de
pierres que ne cassait plus le maillet, mais le

canon" (ibid.). A related parallel was jokingly suggested in a cartoon that appeared soon after the short-lived triumph to which Vallès referred. Here the Communards' destruction of the Vendôme Column, symbol of militarism and imperialism - an act for which Courbet would be held responsible, fined, imprisoned, and driven from France - is paralleled with Courbet's painting of the stonebreakers. Although it would be most tempting to suggest, in part on the basis of Vallès' comment, that the breaking of stones in Courbet's painting involved a <u>latent</u> political symbolism of the type alluded to in these parallels, it would be a shame to subject LES CASSEURS DE

→

"L'homme qui était un jour appelé à démolir la Colonne devait commencer par être casseur de pierres." Léonce Schérer, SOUVENIRS DE LA COMMUNE (4 août 1871). Reprinted in Léger (op. cit.).

83

PIERRES to so contrived an interpretation, which would necessarily be reminiscent of Courbet's joke regarding the search for hidden meanings in LA REMISE DES CHEVREUILS (p. 66 above).

The socialist whose comments on LES CASSEURS DE PIERRES have won the greatest notoriety, is not Vallès, however, but Pierre-Joseph Proudhon, who singled the painting out for special attention in his book, DU PRINCIPE DE L'ART ET DE SA DESTINATION SOCIALE, published posthumously in 1865. Here Courbet is characterized as the first to have succeeded in creating a genuinely socialist work.[18] The major points in Proudhon's discussion of LES CASSEURS DE PIERRES can be briefly summarized as follows:

a) The painting is an indictment of modern, industrial society, which invents machines that can perform every conceivable task, yet which is "incapable d'affranchir l'homme des travaux les plus grossiers, les plus pénibles, les plus répugnants, apanage éternel de la misère." And even if stonebreaking machines _were_ invented, that would still not constitute a liberation, since man would still be a slave to those machines (pp. 236-237).

b) Of the two figures in Courbet's painting, the one who most fully embodies servitude and poverty is not the old man but the boy. Although the old man, whose "bras endroidis se lèvent et tombent avec la régularité d'un levier," is a sad specimen of "l'homme mécanique ou mécanisé," at least he has lived a full life, and has his memories to comfort him; the boy, on the other hand, will know only the abject labor of stonebreaking (pp. 239-240). Why Proudhon assumes that the old man's youth was not like the boy's, is never made clear.

Gustave Courbet, PIERRE-JOSEPH PROUDHON ET SES ENFANTS EN 1853. Begun in 1853, completed in 1865. Oil on canvas, 147 x 198 cm. VILLE DE PARIS, Musée du Petit Palais, Paris.

c) The stonebreakers in Courbet's painting symbolize the plight of the French proletariat (pp. 240-241).

d) The painting is admirably understated - Courbet having refrained from melodramatically juxtaposing poverty and wealth, by placing the stonebreakers before the gate of a château, as Victor Hugo might have done (pp. 241-242).

and e) "Des paysans, qui avaient eu l'occasion de voir le tableau de Courbet, auraient voulu l'avoir pour le placer, deviner où? Sur le maître autel de leur église" (p. 242).

Presumably as part of a strategy for pulling the rug out from under idealist critics who objected to Courbet's materialism (soon to be discussed), Proudhon repeatedly insisted that Courbet's art involved a

marriage of the real and the ideal. However, Proudhon's use of the word 'ideal' in these passages is highly problematic. A single example should suffice:

> Courbet, en effet, saisissant les rapports de la figure corporelle et des affec- tions et facultés de l'âme, de ses habitudes et de ses passions, s'est dit: 'Ce que l'homme est dans sa pensée, son âme, sa conscience, son intelligence, son esprit, il le montre sur son visage et dans tout son être; pour le révéler à lui-même, je n'ai besoin que de le peindre. Le corps est une expression; par conséquent la pein- ture qui le représente et l'interprète est un langage. Un philosophe ferait une psychographie; je ferais un tableau. Déshabillons cet homme, et nous allons voir. Voilà le réalisme de Courbet: la représentation du dehors pour nous montrer le de- dans... Voilà comment Courbet marie ensemble ces deux éléments, l'idéal et le réel, l'imagination et l'observation (pp. 286-287).

Up to this point, I have tried to show a number of ways in which LES CASSEURS DE PIERRES was seen as politically significant. In the remainder of this section, I would like to describe three stategies aimed at doing the opposite - that is, ar- guments designed to deny or to minimize the political significance of the painting, at least as far as Courbet's original intentions were concerned.

The first of these strategies was to argue that Courbet's painting is an expres- sion of pity, not of protest or in any sense a call for change. For example, Riat

stated: "On a dit plus tard que les CASSEURS DE PIERRES était la première oeuvre socialiste du peintre; cependant, cette lettre à Francis Wey, une autre à Champfleury, témoignent qu'il n'y avait mis, à l'origine, que de la pitié pour les déshérités, et non point une protestation violente contre la société" (op. cit., p. 75). Even Champfleury had argued: "Il n'y a pas l'ombre de socialisme dans L'ENTERREMENT A ORNANS; et il ne suffit pas de peindre des casseurs de pierres pour me montrer un vif désir d'améliorer le sort des classes ouvrières."[19] And Jean Leymarie wrote: "Courbet, however, as his letters show, had no didactic or political intention: he had merely been moved to compassion (and a sudden sense of the pictorial possibilities of the scene) by a chance encounter on a road near Ornans..."[20]

We have already seen Courbet's own reply to this attempt to dissociate pity and protest, in his answer to Ideville, cited on page 67 above: "Mais cette pitié, elle résulte d'une injustice..." Riat, incidentally, chose not to include this quotation in his discussion, though he cited other portions of Ideville's text.

Another way of dealing with comments of the type cited above, has been proposed by Jack Lindsay, who wrote:

> We must leave for a moment the full discussion of the relation of Courbet's social-ism and his art; but we may note that most of the arguments at the time, and indeed most of those since, have been on a low level of understanding. It has too often been assumed that a socialist painting means a piece of obvious propaganda approximating to a political cartoon... the desire to paint that patch of roadway with its two stone-breakers came originally from (Courbet's) feeling of the completeness with which they summed up injustice. His remarks during the work on the canvas to

Wey and Champfleury show that he particularly felt this emotion because of the way in which the working-together of the old man and the youth expressed the cycle of unending misery that the system around him perpetuated. He was painting not two workers doing a specially back-breaking job and getting a poor reward for it, but the whole endless cycle of hopeless toil among large sections of the people, the whole endless cycle of exploitation. The strength and fullness with which he felt the nature of the image was determined by the movement to socialism which was going on inside him.[21]

It is interesting to note that commentators citing the same primary sources - such as the letters to Wey and Champfleury (pp. 56-59 above), reach opposite conclusions. While my own sympathies are with the point of view expressed by Lindsay, the reader will probably wish to draw his or her own conclusions on the basis of the documents provided, and the painting itself.

A second strategy commentators have used to marginalize the political significance of LES CASSEURS DE PIERRES, is to suggest that Courbet's primary concern in painting the picture, was with artistic - not social or political - questions. Riat stated categorically that Courbet "pensait encore plus à l'art qu'à la politique, et c'était surtout l'art qu'il voulait réformer," when painting the stonebreakers (op. cit., pp. 75-76). Another early commentator wrote: "En réalité, à cette époque, Courbet songeait bien plus à une réforme artistique qu'à une réforme sociale." [22] And Gerstle Mack has suggested that "there is no reason to believe that Courbet, when he conceived and executed the STONE-BREAKERS, was concerned more than incidentally with the social significance of the subject. The letter to Wey indicates that, although he pitied the wretched labourers and was not

unaware of the tragedy of their hopeless, toilsome, and poverty-stricken lives, he was interested primarily in the pictorial qualities of the scene."[23]

A third strategy, closely related to the one cited above but far more costly in terms of Courbet's public image, consists in asserting that on those occasions when the painter retrospectively alluded to the political meaning of LES CASSEURS DE PIERRES, he was simply parroting ideas Proudhon had fed to him. This view stems primarily - perhaps exclusively - from the following account of a dialogue which reportedly took place between Courbet and Proudhon at the Brasserie Andler:

...N'entendant rien aux questions d'art, qui pourtant excitait la curiosité de son esprit, (Proudhon) venait se renseigner auprès de Courbet, Franc-Comtois comme lui.
 Je me souviens encore d'une bribe de leur conversation.
 - Dites-moi donc, citoyen maître peintre, ce qui vous a amené à faire vos Casseurs de pierres?
 - Mais, répondit le citoyen maître peintre, j'ai trouvé de motif pittoresque et à ma convenance.
 - Quoi? rien de plus?... Je ne puis admettre que l'on traite un pareil sujet sans idée préconçue; peut-être avez-vous songé aux souffrances du peuple, en représentant deux membres de la grande famille manouvrière exercant un métier aussi pénible que peu rétribué?
 - Vous avez raison, maître philosophe, j'ai dû penser à cela.
 Dans la suite il était courant d'entendre dire à Courbet: "On croit que je peins pour le plaisir de peindre, et sans jamais méditer mon sujet... Erreur! mes amis. Il y a toujours dans ma peinture une idée philosophique humanitaire plus ou moins cachée... A vous de la trouver."[24]

A somewhat similar account is provided by Riat. However, it is clearly second-hand and no source is given. Furthermore, Riat's questionable use of the Ideville quote (which the reader will find in its full context on p. 67 above) makes the entire account somewhat suspect:

> Les familiers de la brasserie Andler rapportent que, certain soir, le philosophe (Proudhon) s'efforça de prouver à Courbet qu'il avait fait oeuvre politique; et celui-ci de s'en défendre d'abord, comme un beau diable:
> - C'est ainsi cependant, répliqua Proudhon; n'est-ce pas une oeuvre sociale que de placer de cette façon, à côté d'un homme usé avant l'âge, amaigri prématurément par le travail..., un enfant frais et rose, ne demandant qu'à croître, à se fortifier, à vivre libre au grand soleil, et, pourtant condamné à briser aussi des cailloux, et à devenir vieux à vingt ans?
> Or, M. d'Ideville, qui fréquenta beaucoup l'artiste plus tard, assure que Courbet se rangea bientôt à cet avis, et raconta qu'il avait "sans le vouloir, rien qu'en accusant une injustice, soulevé la question sociale" (op. cit., p. 75).

Unfortunately, there is no way either to verify or to dismiss these accounts by Schanne and Riat. It is generally believed that the friendship between Proudhon and Courbet began in 1848,[25] in which case it would have been entirely possible for the two men to have discussed LES CASSEURS DE PIERRES even before Courbet had written to Wey and Champfleury. It is also believed that Courbet frequented the Brasserie Andler from 1848 on (Lindsay, p. 35). As far as Schanne's first-hand account is concerned, are we to believe that Proudhon and Courbet actually addressed one another as 'citoyen maître peintre' and 'maître

philosophe' respectively? Or are we expected to understand that Schanne was deliberately caricaturing both participants in this reported dialogue, perhaps to make a better story of it? One can only hope that Courbet was not as big a fool as Schanne made him out to be.

THE IDEALIST CRITIQUE OF COURBET'S ESTHETIC

To put matters most simply, Courbet's realism consisted in painting what he saw. As he himself put it in an open letter to a group of students at the École des Beaux-Arts, who had asked him to be their teacher:

> ...Je tiens aussi que la peinture est un art essentiellement concret et ne peut consister que dans la représentation des choses réelles et existantes. C'est une langue toute physique qui se compose, pour mots, de tous les objets visibles. Un objet abstrait, non visible, non existant, n'est pas du domaine de la peinture.
>
> L'imagination dans l'art consiste à savoir trouver l'expression la plus complète d'une chose existante, mais jamais à supposer ou à créer cette chose même.[26]

There had, of course, been 'realist' painting long before Courbet's time,[27] as the reproduction of Le Nain's FAMILLE DE PAYSANS DANS UN INTÉRIEUR (1648) should illustrate (p. 78 above). The reader might also think of such masters as

Vermeer and Rembrandt. But in one respect at least, Courbet probably pushed realism to a farther extreme than had ever been done previously. It is doubtful that anyone before Courbet had painted in the manner described in this account by his friend, Francis Wey:

Il me souvient qu'un jour, devant la pente au-delà de laquelle se relève le coteau de Marcil, il me désigna au loin un objet en disant: "Regardez donc là-bas, ce que je viens de faire? Je n'en sais rien du tout."

C'était un certain bloc grisâtre, dont, à distance, je ne me rendis pas compte; mais jetant les yeux sur la toile, je vis que c'était un massif de fagots. "Je n'avais pas besoin de le savoir, dit-il, j'ai fait ce que j'ai vu sans m'en rendre compte (puis, se reculant devant son tableau), il ajouta: "Tiens, c'est vrai, c'était des fagots." Je certifie qu'il était sincère, étant de ma nature, aussi montagnard que lui.[28]

Courbet chose to paint: a) exactly what he saw; b) only what he saw; and c) whatever he considered to be worthy of pictorial representation. The combination of these three principles brought him to a head-on confrontation with the conservative wing of the cultural establishment of his day, which perceived the real world as essentially degrading and sought in art the possibility of leaving that degradation far behind, by entering a higher, spiritual sphere. This polarization of esthetic principles into realist and idealist camps, was inextricably related to other polarities, with the result that entire constellations of principles were to be found at opposite ends of the spectrum: at one end, realism, materialism, positivism, progress, and democratization in every conceivable way - most visibly

in the choice of humble subjects to portray; at the other end of the spectrum, idealism, spirituality, imagination, and a will to maintain absolute elitist hierarchies, for example with regard to what - and who - was considered worthy of pictorial representation. Those defending the idealist position saw themselves as the embattled guardians of culture, and perceived the realists as intruders from the bottom of the social ladder who were bent on destroying the very spirit of art.[29]

With these general boundaries in mind, three idealist critiques - or rather, three variants of essentially the same idealist critique - of LES CASSEURS DE PIERRES, will now be discussed.

— Ils m'ont refusé ça les ignares !!...

This Daumier lithograph of 1859 ridiculed the realist notion that nothing an artist wishes to paint is unworthy of pictorial representation. Daumier's caption reads: "Ils m'ont refusé ça... les ignares..." From the perspective of this hierarchical ordering of subjects according to worthiness of portrayal, much of Van Gogh's work would have been seen as hilarious.

The first is Louis de Gefroy's attack on Courbet in LA REVUE DES DEUX MONDES in 1851. [30] After preliminaries in which Gefroy derides Courbet as a person claiming to renew art in the form of socialist painting, when in reality he is a throw-back, bent on reversing centuries of artistic progress, the critic goes on to make his central points:

M. Courbet s'est dit: A quoi bon se fatiguer à rechercher des types de beauté qui ne sont que des accidents dans la nature et à les reproduire suivant un arrangement qui ne se rencontre pas dans l'habitude de la vie? L'art, étant fait pour tout le monde, doit représenter ce que tout le monde voit; la seule qualité à lui demander, c'est une parfaite exactitude. Là-dessus, notre penseur plante son chevalet au bord d'une grande route, où des cantonniers cassent des pierres: voilà un tableau tout trouvé, et il copie les deux manoeuvres dans toute leur grossièreté...

C'est grande pitié qu'en l'an 1851 on soit réduit à faire la démonstration des principes les plus élémentaires, à répéter que l'art n'est pas la reproduction indifférente de l'objet le premier passant, mais le choix délicat d'une intelligence raffinée par l'étude, et que sa mission est, au contraire, de hausser sans cesse au-dessus d'elle-même notre nature infirme et discracié. Ils se sont donc trompés, tous les nobles esprits qui, de siècle en siècle, ont entretenu dans l'âme de l'humanité le sentiment d'une destinée supérieure, et nous aussi qui, devant leurs chefs-d'oeuvre, nous sentions allégés, heureux de dérober quelques heures à la pesante réalité? Voici venir les coryphées de l'ère nouvelle qui nous rejettent brutalement la face contre cette terre fangeuse, udam humum, d'où nous enlevait l'aile de la poésie. Ils nous ramènent à la glèbe, ces prétendus libérateurs, et, pour ma part, je n'imagine pas de contrée si barbare dont

le séjour ne fût préférable à celui d'un pays où ces sauvages bêtises viendraient
à prévaloir (pp. 880-882).

The elitism in this passage is unmistakable: "...un choix délicat d'une intelligence
raffinée par l'étude" on one side, and on the other, the "grossièreté" of the two
laborers that should never have been allowed to defile the sphere of art. Reality
- including our own human nature - is vile; art must be a sublime escape to
purer realms.

A second variant of the idealist critique touches on an equally central con-
cern: the relative status of human beings and inert objects. One of Champfleury's
arguments in defense of Courbet was mentioned earlier (on p. 77): "On ne veut
pas admettre qu'un casseur de pierre vaut un prince: la noblesse se gendarme
de ce qu'il est accordé tant de mètres de toile à ces gens du peuple..." This
was in an open letter on realism, addressed to George Sand in L'ARTISTE. In
response to this argument, Charles Perrier sent his own letter on realism to the
same publication, and took issue with Champfleury's defense in the following
terms:

Ce n'est point, comme il l'affirme, parce qu'il a peint des bourgeois et des
paysans que M. Courbet est traité de factieux, mais parce qu'il les a présentés
sous un aspect auquel la nature humaine répugne. Nous avons, avant tout, le sen-
timent de notre dignité. Qu'un casseur de pierres vaille, en fait d'art, un
prince ou tout autre individu, c'est ce que personne ne songe à contester. La
preuve en est, encore une fois, dans l'intérêt qu'inspirent tous les héros de
George Sand. Mais, au moins, que votre casseur ne soit pas lui-même un objet
aussi insignifiant que la pierre qu'il casse.[31]

95

This idea, that Courbet failed to infuse his figures with the breath of life, and instead reduced them to the same status as that of the inert objects around them, was further developed by a third critic, Camille Lemonnier, who devoted an entire book to Courbet.[32] Lemonnier wrote:

Courbet était un paysagiste de l'humanité. Une tête était pour lui un morceau de la matière; ce n'était pas le centre nerveux d'un être organisé pour sentir et penser.

Il faisait de l'homme un accessoire de l'énorme nature morte qui est le fond de son oeuvre (p. 38).

Courbet a été le peintre universel du monde extérieur. Il a peint la pulpe, l'épiderme, l'aspect étalé; il n'est pas descendu dans les profondeurs de la vie. Aussi sera-t-il muet pour l'avenir.

Il n'a pas écrit l'histoire d'une seule existence; il n'a peint ni une tête qui pense ni une âme qui souffre. Le tableau qui est peut-être son chef-d'oeuvre, les CASSEURS DE PIERRES, ont une beauté inaltérable de nature morte, avec des êtres sommeillants, pris aux limites de l'intelligence. C'est une superbe page de peinture; ce n'est pas une page d'histoire. Demeuré inexécuté, elle n'eût pas manqué à l'humanité, elle n'eût privé les esprits ni d'un frisson ni d'une émotion (pp. 41-42)[33]

Even Courbet's pioneering use of the palette knife to apply paint to the canvas, was categorically condemned by Lemonnier as yet another facet of the dehu-

manization Courbet brought to painting:

> Le couteau est un outil inférieur et l'on ne peut méconnaître que Courbet en a ré-
> pandu l'usage parmi les peintres de ce temps. Il est le créateur de cette mauvaise
> habitude; il a importé un vice nouveau dans l'art, et ce vice a mis la peinture
> contemporaine à un doigt de sa perte...
> Un pinceau, c'est de la cervelle.
> Au contraire, le couteau est l'instrument bête du manouvrier; il est incon-
> scient, irresponsable, mécanique (pp. 61, 62).

<p style="text-align:center">*
* *</p>

Both Perrier and Lemonnier reproached Courbet for reducing the stonebreakers to the status of inert objects, like the stones in the picture. In this connection, it might be interesting to consider a statement Champfleury attributed to Courbet. Champfleury wrote:

> Je me rappelle une époque déjà lointaine où, voulant faire comprendre à ceux qui
> vous entouraient que vous dépensiez une force considérable pour vos personnages,
> vous disiez: "Je fais penser les pierres."[34]

The reader may recall an earlier discussion of Courbet's letters to Wey and Champfleury, and Goldmann's concept of a "transfert des fonctions actives des hommes aux objets" (p. 59 above). Would it be too far-fetched to wonder whether, at a certain point in the history of painting, human figures became

more lifeless and inert objects seemingly more alive? One intriguing aspect of this possiblity is that it could provide a common ground for Marxist and idealist analysts of culture. On the other hand, how fair would this be to Courbet? And would it require a 'strategically selective' sampling of paintings to support the hypothesis? I suspect that would be the case, as it so often is with models of this type. In any event, the possibility of even beginning to test this hypothesis lies outside the range of the present study of a single work.

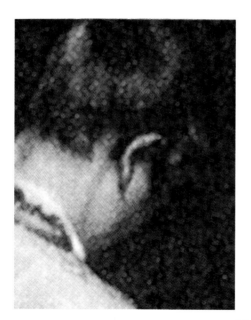

ON THE STONEBREAKERS' FACELESSNESS: SIX INTERPRETIVE OPTIONS

The scene portrayed in LES CASSEURS DE PIERRES is staged in such a way that the boy's face is turned entirely away from the viewer, and the profile of the old man is concealed to a point below his eye by the brim of his hat, with much of the remainder of his face obscured by the shadow of the hat. By and large, both figures can be considered to be faceless. This aspect of the painting has been, or might be, interpreted in at least six different ways:

1) The simplest explanation is to suggest - as R. Broby-Johansen did [35] - that the absence of faces emphasizes the anonymity of the figures. They are presented as types, not individuals. In this respect, it could be argued that Courbet did everything he could to avoid individualizing portraiture in this painting.

2) A second interpretation seeks to explain the anonymity of the figures in other terms: as an acknowledgment on Courbet's part that he - as a financially comfortable bourgeois painter - had no real insight into, or basis for identifying with, the rural laborers he portrayed. While I personally find this position unconvincing, it is well worth considering here, in the terms in which T. J. Clark proposed it:

> When Courbet makes his actors anonymous - as he does, for instance, in the STONEBREAKERS - it seems as if this is something he works towards, against the grain of his particular, concrete intelligence. In the STONE-

BREAKERS, everything is particular except the two men's faces, and feelings; and they are masked because Courbet saw, in the end, that they were the only things in the scene he did not know or understand (op. cit., p. 74).

Lest there should be any confusion about the direction of my argument as to the 'personal' nature of UN APRÈS-DÎNER À ORNANS as compared with anonymity of LES CASSEURS DE PIERRES, let me say that it seems to me an achievement to see and represent one's personal involvement in an institution or a class situation, when that involvement is a reality, even if a hidden one... Equally, it is an achievement - and in this case a rare one - to avoid such a reading of a class-situation or a work-situation, when avoidance of personal reference corresponds to the facts: the 'facts' of a bourgeois's radical incomprehension of the psychology of the working man, for instance. Hence the anonymity of LES CASSEURS DE PIERRES, as opposed to the conventional bourgeois reading of such scenes in terms of a personal tragedy or a generalized, but 'individual', dignity of labour (p. 178, note 6).

3) Michael Fried, whose comments on the figure reversal were discussed earlier (pp. 16-19 above), suggested that Courbet strove, in his self-portraits of the 1840's, "to transpose himself as if corporeally into the painting on which he was working," which resulted in "representations of the sitter in extreme proximity to the picture surface, wholly or partly from the rear" (op. cit., p. 634). With respect to the facelessness of the stonebreakers, Fried goes on to ask:

What are we to make of so eccentric a choice of aspect, and, incidentally,
how can it be squared with an alleged concern with directness and immediacy?
Is it enough to say that by refusing to show us his protagonists' faces the
painter has underscored the anonymity (and, Clark would add, the alienness
to a bourgeois observer such as Courbet was) of ceaseless back-breaking labor
at the bottom of the social scale? Or is it necessary to connect the peculiar
facelessness of the stonebreakers... with the tendency evident throughout
the early self-portraits to depict the sitter in some measure from the rear?
(p. 638)

What Fried apears to be driving at in these and subsequent passages, is that
the stonebreakers are faceless because they are projections of the painter
(or 'painter-beholder') into the picture - which, according to Fried, also ex-
plains why the figures are in the extreme foreground, close to the surface
of the painting (pp. 638, 640). This would appear to be Courbet's way of
managing the anti-theatrical tradition which demands that the painter con-
trive "the fiction, the meta-illusion, that the beholder does not exist, that
there is no one standing before the picture" (p. 619).

4) A most interesting interpretation was proposed by the painter, Odilon
Redon, who suggested that the stonebreakers are faceless because they have
been reduced to objects by their dehumanizing labor:

Le soleil tombe d'aplomb et direct sur cette route sans joie, où le travail est
morne, presque sans espoir. Ces deux choses informes (deux paysans tels que les

eût vus La Bruyère) s'agitent passivement comme des mécaniques de bois. Pas un visage humain, les regards sont cachés: c'est ici la torpeur inconsciente et automatique de la vie, c'est l'ankylose, l'abaissement profond et fatal de l'animal enchaîné. Comme dans Rembrandt, il y a des sous-entendus profonds et humanitaires, une suprême ressort ici sous forme d'enseignement. C'est qu'une réalité humaine, même fortuite, peut contenir une reproche d'outre-siècle, et peut participer, par sa durée, à la marche infinie vers le mieux...[36]

This can, of course, be seen in relation to Courbet's own description of the painting in his letter to Champfleury (p. 58 above), in which he characterized the old man as a "vieille machine raidie" with arms which "paraissent à ressorts." This is also the best defense of Courbet against the idealist critique proposed by Perrier and Lemonnier, since it acknowledges the lifelessness of the figures, but makes that the deliberate point of the painting.

5) While Redon gave Courbet credit for showing the dehumanizing effect of mindless labor in LES CASSEURS DE PIERRES, the idealist critics just mentioned (and discussed on pp. 95-97 above) saw the dehumanization of the stonebreakers as symptomatic of Courbet's own inability as a painter to breathe life into a human subject. Though they did not explain facelessness per se in this connection, that would certainly be a logical extension of their argument, insisting as they did on what they saw as Courbet's tendency to paint people as though they were part of a still-life.

6) My own view has this much in common with Fried's: that the relationship between the viewer and the figures in the painting is the essential factor. But while Fried deals with this issue in terms of the painter's self-projection into the figures, I find it more appropriate to see the painter as having staged the scene in such a way that the two stonebreakers seem unaware of the viewer's presence - the opposite of the situation in Manet's OLYMPIA (1863), in which the reclining woman almost seems to stare down the viewer; or for that matter, in Le Nain's FAMILLE DE PAYSANS DANS UN INTÉRIEUR (p. 78). In LES CASSEURS DE PIERRES, the figures appear to be not only isolated from one another - each profoundly absorbed in his labor, as a number of commentators have pointed out - but also totally unaware that they are in our field of vision. Curiously, Fried finds in Courbet's predecessors ("From Greuze through Géricault") representations of figures "that would strike one as absolutely immured in the world of the painting and a fortiori as oblivious to the very possibility of being viewed" (p. 620) - while Courbet's own work is seen in the very different terms already described.

I don't mean to suggest that the stonebreakers are turning their back on the viewer, but rather that in staging the scene as he did, Courbet emphasized the solitude of the stonebreakers, even in relation to the onlooker. In the process, he also avoided any hint of pathos, opting instead for an admirable restraint or pudeur in not placing the figures' faces on display.

NOTES

[1] Letter to M. and Mme Francis Wey. First published in ARCHIVES HISTORIQUES, ARTISTIQUES ET LITTÉRAIRES, vol. I, 1889-1900 (Paris: Étienne Charavey), p. 35. Reprinted in COURBET RACONTÉ PAR LUI-MÊME ET PAR SES AMIS, ed. Pierre Courthion (Geneva: Pierre Cailler, 1950), vol. 2, pp. 75-76.

[2] Letter to Champfleury, reprinted in T. J. Clark, IMAGE OF THE PEOPLE. GUSTAVE COURBET AND THE 1848 REVOLUTION (London: Thames & Hudson, 1973), p. 166; no source given.

[3] "Nouveau roman et réalité," in POUR UNE SOCIOLOGIE DU ROMAN (Paris: Gallimard, 1964), pp. 288, 295.

[4] The following passage on LES CASSEURS DE PIERRES is found in another book, published the same year as Riat's study of Courbet: "...Cette page singulière, bizarre, forçait néanmoins l'attention; elle était empreinte d'un ton de sauvage tristesse, qui n'était point habituelle au peintre. Courbet l'appréciait, et disait en contemplant les deux travailleurs rivés au servage: 'Pauvres gens! J'ai voulu résumer leur vie dans l'angle de ce cadre, n'est-ce pas qu'ils ne voient jamais qu'un petit coin du ciel." A. Estignard, COURBET. SA VIE, SES OEUVRES (Besançon: Delagrange -Louys, 1906), p. 25. Neither Riat nor Estignard indicate a source for the quotation.

[5] Merete Lund and Benedikte H. Nielsen, KULTURELLE STRØMNINGER I FRANKRIG 1830-1880 (Copenhagen: Det Teatervidenskabelige Institut, 1985), p. 73, my translation. The authors also interestingly characterize Courbet's painting as almost claustrophobic, because of the smallness of the triangle of sky.

[6] GUSTAVE COURBET. A STUDY OF STYLE AND SOCIETY (New York & London: Garland Press, 1976), pp. 149-150.

[7] Comte H. d'Ideville, GUSTAVE COURBET. NOTES ET DOCUMENTS SUR SA VIE ET SON OEUVRE (Paris: Alcan-Lévy, 1878), pp. 37-38.

[8] Louis de Gefroy, "Salon de 1850," REVUE DES DEUX MONDES (1851), 1, p. 881.

[9] Clark (op. cit.), p. 172.

[10] John B. Wolf, FRANCE 1814-1919 (New York: Harper & Row, 1963; orig. pub. 1940), pp. 205-206.

[11] Jules Castagnary, "Fragments d'un livre sur Courbet," 2e partie, GAZETTE DES BEAUX-ARTS 6 (1911), p. 496. This passage appears as well on pp. 11-12 in the CATALOGUE DE L'EXPOSITION DES OEUVRES DE GUSTAVE COURBET À L'ÉCOLE DES BEAUX-ARTS, May 1882.

[12] COURBET (Paris: Bernheim-Jeune, 1918), p. 27.

[13] REALISM IN ART (New York: International Publishers, 1954), p. 128.

[14] "Du réalisme. Lettre à Mme Sand," L'ARTISTE, 2 September 1855. Reprinted in Champfleury, LE RÉALISME. Textes choisis et présentés par Geneviève et Jean Lacambre (Paris: Hermann, 1973), p. 172. Charles Perrier's response to this counter-attack of Champfleury's will soon be discussed.

[15] Published in LE PEUPLE, JOURNAL DE LA RÉVOLUTION SOCIALE on June 7, 1850. Reprinted in an appendix in Clark (op. cit.), pp. 162-164.

[16] L'ÉVÉNEMENT, 11 March 1866. Reprinted in JULES VALLÈS - LE CRI DU PEUPLE, ed. Lucien Scheler (Paris: EFR, 1953), p. 411.

[17] LE RÉVEIL, 26 June 1882; ibid. p. 261. I can't help wondering whether it was entirely fair to make this judgment. In the wake of the unprecedented experiments with light and color that were still being carried out by the impressionists in 1882, what painting done in the 1840's or 1850's would not have looked somewhat dull in comparison?

[18] The first sentence in the section on LES CASSEURS DE PIERRES reads: "D'autres, avant Courbet, on essayé de la peinture socialiste, et n'ont pas réussi," p. 236 of the facsimile edition (Westmead: Gregg International Publishers, 1971), based on the 1865 Garnier edition.

[19] Champfleury, "Courbet - L'ENTERREMENT À ORNANS 1851," in GRANDES FIGURES D'HIER ET D'AUJOURD'HUI (Paris: Poulet-Malassis et De Broise, 1861), p. 236.

[20] FRENCH PAINTING IN THE NINETEENTH CENTURY (Geneva: Skira, 1962), p. 137.

[21] GUSTAVE COURBET. HIS LIFE AND ART (Somerset: Adams & Dart, 1973), pp. 59-60.

[22] G. Gazier, GUSTAVE COURBET, L'HOMME ET L'OEUVRE (Besançon: no publisher listed, 1906), p. 21.

[23] GUSTAVE COURBET (Westport: Greenwood Press, 1970; orig. pub. 1951), pp. 70-71.

[24] Alexandre Schanne, LES SOUVENIRS DE SCHAUNARD (Paris: Charpentier, 1886), pp. 300-301.

[25] Readers interested in the relationship between Proudhon and Courbet, are referred to James Henry Rubin's REALISM AND SOCIAL VISION IN COURBET AND PROUDHON (Princeton: Princeton University Press, 1980).

[26] COURRIER DU DIMANCHE, 25 December 1861; reprinted in Charles Léger, COURBET (Paris: Crès, 1929), p. 87.

[27] Even Champfleury, one of the major proponents of realism at the time, admitted: "Quant au réalisme, je regarde le mot comme une des meilleures plaisanteries de l'époque. ...le réalisme est aussi vieux que le monde et de tout temps il y a eu des réalistes; mais les critiques, en employant perpétuellement ce mot, nous ont fait une obligation de nous en servir." Cited in Emile Bouvier's LA BATAILLE RÉALISTE (Geneva: Slatkine Reprints, 1973; orig. pub. 1913?), p. 249. Courbet's own notice in the catalogue for his 'Pavillon du réalisme' in 1855, also began with the words: "Le titre de réaliste m'a été imposé comme on a imposé aux hommes de 1830 le titre de romantiques."

[28] "Notre Maître Peintre Gustave Courbet," MÉMOIRES INÉDITS in Pierre Courthion, COURBET RACONTÉ PAR LUI-MÊME ET PAR SES AMIS (Geneva: Pierre Cailler, 1950), pp. 190-191.

[29] I hope the reader will forgive me for this cursory presentation of the idealist position. For a fuller and more sympathetic discussion, the reader is referred to Baudelaire's SALON DE 1859, especially the sections entitled "Le public moderne et la photographie," "La reine des facultés," and "Le gouvernement de l'imagination," pp. 767-780 of Baudelaire's OEUVRES COMPLÈTES (Paris: Pléiade, 1954); and to Ferdinand Brunetière's "La renaissance de l'idéalisme" (1896) in his DISCOURS DE COMBAT (Paris, 1920), pp. 3-57.

[30] "Salon de 1850," REVUE DES DEUX MONDES (1851), 1, pp. 878-915.

[31] "Du réalisme. Lettre à M. le Directeur de L'ARTISTE," appearing in that publication on Oct. 14, 1855, p. 88; cited by Bernard Weinberg in FRENCH REALISM: THE CRITICAL REACTION (New York: MLA, 1937), p. 112.

[32] GUSTAVE COURBET ET SON OEUVRE (Paris: Alphonse Lemerre, 1888).

[33] From our own vantage point, over forty years after the painting has been lost, Lemonnier's statement - that if it had never been painted, it would not have been missed - seems particularly frivolous.

[34] "Lettre confidentielle à mon ami Courbet," in LE RÉALISME (op. cit.), p. 190. According to Riat, it was Proudhon who had invented the formula: " - Je fais penser les pierres, avait dit l'artiste à (Proudhon), oubliant que c'était celui-ci qui lui avait fait, non sans difficulté, cette opinion à propos des Casseurs" (Riat, op. cit., p. 107).

[35] HJEMMETS PINAKOTEK. HOVEDVÆRKER I EUROPÆISK MALERKUNST FRA ISTIDEN TIL IDAG (Copenhagen: Gyldendal, 1960), p. 241.

[36] A SOI-MÊME. JOURNAL 1867-1915 (Paris: Floury, 1922), p. 153. It is very much to Redon's credit that his admiration for Courbet's painting was so great, despite the fact that the realist esthetic it embodied was

diametrically opposed to the haunting,
dream-like imagery Redon cultivated in his
own work. One might otherwise have expected
the same disapproval Redon expressed regard-
ing Manet, when he stated: "Le défaut de
M. Manet et de tous ceux qui, comme lui,
veulent se borner à la reproduction tex-
tuelle de la réalité, est de sacrifier
l'homme et sa pensée à la bonne facture,
à la réussite d'un accessoire" (1868); cited
by John Rewald in his HISTOIRE DE L'IM-
PRESSIONNISME (Paris: Livre de poche, 1955),
vol. 1, p. 233.

APPENDIX : A NOTE ON THE DIMENSIONS OF "LES CASSEURS DE PIERRES"

In catalogue entries, as wel as books and articles on Courbet, the figures given for the height and width of LES CASSEURS DE PIERRES vary to an extraordinary degree as the following table will clearly indicate:

source of reported figures	height	width
Notice, private exhibition at Besançon, May 1850; reproduced in Théophile Silvestre's HISTOIRE DES ARTISTES VIVANTS (Paris: Blanchard, 1855), p. 255.	2.20 m	3 m
Catalogue, Courbet exhibition, École des Beaux-Arts, May 1882; p. 34.	1.65 m	2.38 m
Catalogue, Courbet exhibition, Petit Palais, May-June 1919; p. 12. Catalogue, Courbet exhibition, Zürich Kunsthaus, Dec. 1935-March 1936; p. 59. Michael Nungesser's article, "Die Steinklopfer" (op. cit.), p. 560. Print issued by VEB E. A. Seemann, Leipzig.	$1.58\frac{1}{2}$- 1.59 m	2.59 m
Jack Lindsay, GUSTAVE COURBET. HIS LIFE AND ART (Somerset: Adams & Dart, 1973).	0.91 m	1.15 m
Catalogue, Courbet exhibition, Grand Palais, 30 Sept 1977-2 Jan 1978; p. 28.	1.90 m	3.00 m
Personal communication from the Staatliche Kunstsammlungen Dresden, 25 May 1988.	1.59 m	2.39 m
R. Fernier, LA VIE ET L'OEUVRE DE G. COURBET. CATALOGUE RAISONNÉ (Lausanne and Paris: Fondation Wildenstein, 1977), vol. 1, p. 62. P. Courthion, TOUT L'OEUVRE PEINT DE G. COURBET (Paris: Flammarion, 1985), p. 77. COURBET UND DEUTSCHLAND (Köln: DuMont, 1978), p. 9.	1.65 m	2.57- 2.59 m

How discrepancies of this magnitude could exist between the various reported figures, we will never know. Might the painting have been reframed in such as a way as to give rise to differing measurements, or might it have been reduced in size at some point? If the idea did not raise more difficult problems than it solved, it might even be tempting to wonder whether there could have been more than one full-sized version in circulation, especially since the painting seems to have been owned simultaneously by two different parties in the 1880's and 1890's (see pp. 11 above and 113 below). But if any detective work is worth undertaking with regard to LES CASSEURS DE PIERRES, it should be aimed at recovering the painting that disappeared in Dresden in 1945, rather than spent on fruitless speculation as to why the reported measurements differ so markedly.

However, I believe I have been able to determine the correct measurements of the missing painting, on the basis of a photograph taken at the Courbet exhibition at the École des Beaux-Arts in 1882, in which LES CASSEURS DE PIERRES is seen flanked by two paintings whose dimensions are known. The photo (p. 110) was reproduced in Eckhard Schaar's "Courbet und die Photographie," in COURBET UND DEUTSCHLAND (Köln: DuMont, 1978), p. 554, and is one of the twenty-three plates comprising Eugène Chéron's ALBUM DE L'EXPOSITION DES OEUVRES DE GUSTAVE COURBET A L'ECOLE DES BEAUX-ARTS (1882).

To the upper left of LES CASSEURS DE PIERRES is a painting called LE CHASSEUR ALLEMAND (1859), presently at the Musée Lons-le-Saunier, and measuring 1.19 x 1.75 m. To the upper right is LE CHEVAL DE CHASSE SELLE (1863), belonging to the Städtische Kunsthalle Mannheim, and measuring 1.105 x 1.36 m. (I obtained this figures directly from the curators of the two museums; the figures differ only slightly from those found in the literature.)

Robert Stensgaard, of the Physics Department at Aarhus University, measured the three paintings for me as they appear in the photograph, and with the aid of the figures he provided, I was able to calculate the probable height and width of LES CASSEURS DE PIERRES as being 1.59 x 2.56 m. However, making allowances for some optical distortion, I would suggest that the figures given in the Petit Palais and Zurich exhibition catalogues be regarded as the most reliable: namely 1.58½-1.59 x 2.59 m.

EXPOSITION DE TABLEAUX

M. Gustave Courbet, d'Ornans (médaille d'or de 1849 et maître peintre), momentanément à Besançon, exposera ses tableaux dans la *salle des Concerts, place de l'Abondance.*

1. *Tableau historique d un Enterrement à Ornans,* toile de 7 mètres de longueur: largeur 3 mètres 40 centimètres;

2. *Les Casseurs de pierres,* toile de 3 mètres de longueur: largeur 2 mètres 20 centimètres.

3. *Vue des ruines du château de Scey-en-Varais* (paysage).

4. *Les bords de la Loue sur le chemin de Maizières* (paysage).

Cette Exposition durera quelques jours et sera ouverte mardi prochain, 7 mai, de 10 heures du matin à 5 heures du soir.

Prix-d'entrée : 50 centimes.

A notice from one of the private exhibitions Courbet organized in 1850. Note the dimensions attributed to the painting. Document reproduced in Th. Silvestre's HISTOIRE DES ARTISTES VIVANTS (Paris: Blanchard, 1855), p. 255. Although Silvestre situates this exhibition in 1851, it did in fact take place in 1850 (when the 7th of May was a Tuesday).

Entry in the catalogue of the May 1882 exhibition at the École des Beaux-Arts (p. 34).

This catalogue entry, as well as three other sources, all attribute ownership of LES CASSEURS DE PIERRES to M. Georges Petit - the other sources being: a) a letter Courbet wrote to Castagnary in 1869, stating that the painting had been sent to the Munich exhibition without his knowledge by M. Petit (the letter will be found in COURBET UND DEUTSCHLAND, op. cit., p. 337); b) Estignard's book of 1906 (op. cit., p. 155); and c) the catalogue of the 1929 exhibition at the Petit Palais ("LES CASSEURS DE PIERRES, oeuvre splendide, sont à M. Georges Petit," p. 12). However, other sources, including Aragon's L'EXEMPLE DE COURBET (Paris: Cercle d'Art, 1952), p. 203, and Robert Fernier's exhaustively researched CATALOGUE RAISONNÉ (op. cit.), p. 62, indicate that the painting was acquired by M. Binant in 1871, and remained in the Binant collection until 1904. Georges Petit was apparently involved in the purchase of the small oil sketch now at Winterthur (Fernier, p. 62), but it is difficult to understand how ownership of the full-sized painting could have been misattributed to him on so many occasions, at least some of which cannot have involved a confusion of the oil sketch and final painting since the measurements provided - as in the catalogue entry shown here - preclude that possibility. In any event, the 1929 attribution to Georges Petit is certainly incorrect, since the painting had definitely been acquired by the Dresden museum in 1904.

I find this matter as difficult to sort out as it is to explain why the reported measurements of the painting should vary so significantly - not to mention the biggest mystery of all: the as yet unexplained disappearance of the painting in 1945.

PICTURE CREDITS

The color picture on the front cover is based on a print issued by VEB E. A. SEEMANN Verlag, Leipzig, which was used with the kind permission of that publisher. The color reproduction of the oil sketch on p. 15 was provided by the Oskar Reinhart Collection, "Am Römerholz," Winterthur. The Courbet Museum at Ornans provided the drawing on p. 52, and use of the photograph of the Danish stonebreaker on p. 54 was authorized by Gyldendal. The Metropolitain Museum of Art provided the photographs of the Manet oil paintings on pp. 42 and 43. Photographs of the Manet water-color on p. 42, the paintings by Millet on pp. 61 and 62, by Tassaert and Pils on pp. 64 and 65, as well as Courbet's LA REMISE DES CHEVREUILS and UN ENTERREMENT À ORNANS, pp. 67 and 80, and Le Nain's FAMILLE DE PAYSANS DANS UN INTÉRIEUR, p. 78, were supplied by the Service photographique de la Réunion des Musées Nationaux in Paris. Permission to reproduce the two posters of the 'Ateliers Nationaux' on pp. 74 and 75 was granted by the Bibliothèque Nationale in Paris. The photograph of the 'sabotiers' on p. 44 is used with the permission of La Documentation Française. Courbet's CRIBLEUSES DE BLÉ, p. 31, is reproduced with the authorization of the Musée des Beaux-Arts in Nantes, and Courbet's portraits of Vallès (p. 82) and Proudhon (p. 85), are reproduced with the authorization of the Musée Carnavalet and the Musée Petit Palais, respectively. The Musée Fabre at Montpellier, La Gazette des Beaux-Arts and M. Klaus Berger authorized the reproductions on p. 38. In some few cases, replies to requests for authorization have not yet been received, and in several other cases, efforts to locate the copyright holders of certain materials have proved unsuccessful. However, every effort has been made to secure permission for the use of all copyright materials.

ACKNOWLEDGMENTS

A number of colleagues at Aarhus University provided indispensable assistance of one kind or another - either in solving problems of a practical nature, requiring special skills, or in providing advice or support: I am particularly indebted to Robert Stensgaard, at the Physics Department; Mette Kunøe, Department of Scandinavian Studies; Anders Troelsen, Art Department; Vagn Outzen, Department of Romance Languages; and Povl Lind-Petersen, photographer at the Art Department. I am also very grateful to Hans-Jörg Göpfert, Wiss. Mitarbeiter, Staatliche Kunst-sammlungen Dresden, for taking the time to provide invaluable information, and to Dr. Lisbeth Stähelin, curator of the Oskar Reinhart Collection, "Am Römerholz," Winterthur, for helping with photographic materials and for most informative letters. Other curators I wish to thank include: M. Jean-Jacques Fernier, Courbet Museum, Ornans; M. Bourgeois-Lechartier, Musée de Lons-le-Saunier; Dr. Roland Dorn, Städtische Kunsthalle Mannheim; M. Bernard de Montgolfier, Musée Carnavalet, Paris; Mme Thérèse Burollet, Musée du Petit Palais, Paris; M. Henri-Claude Cousseau, Musée des Beaux-Arts, Nantes; and M. Aleth Jourdan, Musée Fabre, Montpellier. I would also like to express my appreciation to Export Manager, Frau Wille, at VEB E. A. Seemann-Verlag in Leipzig; Mme Céline Kadar, La Documentation Française; Mme Véronique Sulzer, La Gazette des Beaux-Arts; M. Klaus Berger, whose 1943 article on Courbet remains a classic; Ida Andersen, Lars Christian Kortholm, Hélène Wehner Rasmussen, and as always, Aage Jørgensen. Above all, I am grateful to Marilyn Raskin for her suggestions and encouragement.

A grant from the Humanities Faculty at Aarhus University enabled me to complete research for this project in Paris in the summer of 1988, and the publication of this book was made possible by a grant from Aarhus University's Research Foundation.

Aragon. L'EXEMPLE DE COURBET. Paris: Éditions Cercle d'Art, 1952.

Arnheim, Rudolf. ART AND VISUAL PERCEPTION. Berkeley & Los Angeles: Univ. of California Press, 1969; orig. pub. 1954.

Arnheim, Rudolf. THE POWER OF THE CENTER. Berkeley: Univ. of California Press, 1982.

Baudelaire, Charles. OEUVRES COMPLÈTES. Paris: Pléiade, 1954.

Bénédite, Léonce. COURBET. Paris: Renaissance du Livre, n.d.

Berger, Klaus. "Courbet in his Century," GAZETTE DES BEAUX-ARTS 24 (1943), pp. 19-40.

Boas, George. COURBET AND THE NATURALISTIC MOVEMENT. New York: Russell & Russell, 1967; orig. pub. 1938.

Borel, Pierre. LETTRES DE GUSTAVE COURBET À ALFRED BRUYAS. Geneva: Pierre Cailler, 1951.

Bourdaille, Georges. GUSTAVE COURBET. Paris: Nouvelles Éditions Françaises, 1981.

Bouvier, Émile. LA BATAILLE RÉALISTE 1844-1857. Geneva: Slatkine Reprints, 1973; orig. pub. 1913.

Broby-Johansen, R. HJEMMETS PINAKOTEK. HOVED-VÆRKER I EUROPÆISK MALERKUNST FRA ISTIDEN TIL IDAG. Copenhagen: Gyldendal, 1960.

Broby-Johansen, R. DAGENS DONT GENNEM ÅR-TUSINDERNE. HISTORIEN OM ARBEJDSBILLEDET. Copenhagen: Gyldendal, 1969.

Buswell, Guy Thomas. HOW PEOPLE LOOK AT PIC-TURES. Chicago: Univ. of Chicago Press, 1935.

Castagnary, Jules. "Fragments d'un livre sur Courbet," GAZETTE DES BEAUX-ARTS 5 (1911), pp. 1-20; 6 (1911), pp. 488-497; 7 (1912), pp. 19-30.

Champfleury (Jules Husson). LE RÉALISME. Textes choisis et présentés par Geneviève

et Jean Lacambre. Paris: Hermann, 1973.

Champfleury (Jules Husson). GRANDES FIGURES D'HIER ET D'AUJOURD'HUI. Paris: Poulet-Malassis et de Broise, 1861.

Chirico, Giorgio de. GUSTAVE COURBET. Rome: Editions de 'Valori Plastici,' 1925.

Clark, T. J. THE ABSOLUTE BOURGEOIS. ARTISTS AND POLITICS IN FRANCE 1848-1851. London: Thames & Hudson, 1973.

Clark, T. J. IMAGE OF THE PEOPLE. GUSTAVE COURBET AND THE 1848 REVOLUTION. London: Thames & Hudson, 1973.

Courthion, Pierre. GUSTAVE COURBET. Paris: Floury, 1931.

Courthion, Pierre (ed). COURBET RACONTÉ PAR LUI-MÊME ET PAR SES AMIS. 2 vols. Geneva: Pierre Cailler, 1948-1950.

Courthion, Pierre. TOUT L'OEUVRE PEINT DE GUSTAVE COURBET. Paris: Flammarion, 1987; orig. pub. 1985.

Dittmann, Lorenz. "Courbet und die Theorie des Realismus." Sonderdruck aus BEITRÄGE ZUR THEORIE DER KÜNSTE IM 19.JAHRHUNDERT. Frankfurt, 1971; pp. 215-239.

Doesschate Chu, Petra ten (ed). COURBET IN PERSPECTIVE. Englewood Cliffs: Prentice-Hall, 1977.

Durbé, Dario. COURBET E IL REALISMO FRANCESE. Milan: Fratelli Fabbri Editori, 1969.

Duret, Théodore. COURBET. Paris: Bernheim-Jeune, 1918.

Ellis, Andrew W. and Diane Miller. "Left and Wrong in Adverts: Neuropsychological Correlates of Æsthetic Preference," BRITISH JOURNAL OF PSYCHOLOGY 72 (1981), pp. 225-229.

Estignard, A. COURBET. SA VIE, SES OEUVRES. Besançon: Delagrange-Louys, 1906.

Fermigier, André. COURBET. Geneva: Skira, 1971.

Fernier, Robert. LA VIE ET L'OEUVRE DE GUSTAVE

COURBET. CATALOGUE RAISONNÉ. Vol. 1: 1819-1865. Lausanne & Paris: Fondation Wildenstein, 1977.

Finkelstein, Sidney. REALISM IN ART. New York: International Publishers, 1954.

Fontainas, André. COURBET. Paris: Felix Alcan, 1921.

Fried, Michael. "Painter into Painting: On Courbet's AFTER DINNER AT ORNANS and STONEBREAKERS," CRITICAL INQUIRY 8 (Summer 1982), pp. 619-649.

Fried, Michael. "The Structure of Beholding in BURIAL AT ORNANS," CRITICAL INQUIRY 9 (June 1983), pp. 635-683.

Gaffron, Mercedes. "Right and Left in Pictures," ART QUARTERLY 13 (1950), pp. 312-331.

Gazier, G. GUSTAVE COURBET. L'HOMME ET L'OEUVRE. Besancon: no pub. listed, 1906.

Gefroy, Louis de. "Le Salon de 1850," REVUE DES DEUX MONDES (1851), 1, pp. 878-915.

Gilbert, Christopher & Paul Bakan. "Visual Asymmetry in Perception of Faces," NEUROPSYCHOLOGIA 11 (1973), pp. 355-362.

Groner, Rudolf et al. "Looking at Faces: Local and Global Aspects of Scanpaths," in THEORETICAL AND APPLIED ASPECTS OF EYE MOVEMENT RESEARCH. Amsterdam: Elsevier, 1984, pp. 523-533.

Gros-Kost, E. COURBET. SOUVENIRS INTIMES. Paris: Derveaux, 1880.

Gross, Charles G. and Marc H. Bornstein. "Left and Right in Science and Art," LEONARDO 11 (1978), pp. 29-38.

Hauser, Arnold. THE SOCIAL HISTORY OF ART. New York: Vintage, n.d.; orig. pub. 1951.

Herbert, Robert L. "City vs Country: The Rural Image in French Painting from Millet to Gauguin," ARTFORUM (Feb 1970), pp. 44-55.

Huyghe, René. LA RELÈVE DE L'IMAGINAIRE. RÉALISME, ROMANTISME. Paris: Flammarion, 1976.

Ideville, Comte H. d'. GUSTAVE COURBET. NOTES ET DOCUMENTS SUR SA VIE ET SON OEUVRE. Paris: Alcan Lévy, 1878.

Kashey, Robert J. F. and Martin L. H. Reymert. CHRISTIAN IMAGERY IN FRENCH NINETEENTH CENTURY ART 1789-1906. New York: Shepherd Gallery, 1980.

Kashnitz, Marie Luise. DIE WAHRHEIT, NICHT DER TRAUM. DAS LEBEN DES MALERS COURBET. Frankfurt: Insel, 1967; orig. pub. 1950.

Koella, Rudolf. SAMMLUNG OSKAR REINHART. Zurich: Orell Füssli Verlag, 1975.

Le Bailly de Tilleghem, Baron Serge. L'ART SOCIAL AU MUSÉE DES BEAUX-ARTS DE TOURNAI. Liège and Bruxelles: Pierre Mardaga, 1987.

Léger, Charles. COURBET. Paris: Crès, 1929.

Léger, Charles. COURBET SELON LES CARICATURES ET LES IMAGES. Paris: Paul Rosenberg, n.d.

Lemonnier, Camille. GUSTAVE COURBET ET SON OEUVRE. Paris: Alphonse Lemerre, 1888.

Levy, Jerre. "Lateral Dominance and Æsthetic Preference," NEUROPSYCHOLOGIA 14 (1976), pp. 431-445.

Lindsay, Jack. GUSTAVE COURBET. HIS LIFE AND ART. Somerset: Adams & Dart, 1973.

Lund, Merete and Benedikte H. Nielsen. KULTUR-ELLE STRØMNINGER I FRANKRIG 1830-1880. Det Teatervidenskabelige Institut, Copenhagen, 1985.

Mack, Gerstle. GUSTAVE COURBET. Westport: Greenwood Press, 1970; orig. pub. 1951.

Mackie, Alwynne. "Courbet and Realism," ART INTERNATIONAL 22, 7 (Nov-Dec 1978), pp. 36-40, 61.

MacOrlan, Pierre and Anna Marsan. COURBET. Paris: Éditions du Dimanche, 1951.

Mantz, Paul "Gustave Courbet," GAZETTE DES BEAUX-ARTS 17, 6 (June 1878), pp. 514-527; 18, 1 (July 1878), pp. 17-30; 18, 6 (Dec 1878), pp. 371-383.

McCarthy, James C. "Courbet's Ideological Contradictions and THE BURIAL AT ORNANS," ART JOURNAL 35, 1 (Fall 1975), pp. 12-16.

McManus, I. C. and N. K. Humphrey. "Turning the Left Cheek," NATURE 243 (1973), pp. 27-

Menz, Henner. DRESDNER BILLEDGALLERI. Copenhagen: Munksgaard, n.d.

Nielsen, T. M. and G. MacDonald. "Lateral Organization, Perceived Depth and Title Preference in Pictures," PERCEPTUAL AND MOTOR SKILLS 33 (1971), pp. 983-986.

Nochlin, Linda. REALISM. Middlesex: Penguin, 1971.

Nochlin, Linda. GUSTAVE COURBET. A STUDY OF STYLE AND SOCIETY. New York and London: Garland Press, 1976.

Noton, David and Lawrence Stark. "Scanpaths in Saccadic Eye Movements While Viewing and Recognizing Patters," VISION RESEARCH 11 (1971), pp. 929-942.

Nungesser, Michael. "Die Steinklopfer," in COURBET UND DEUTSCHLAND. Köln: DuMont, 1978, pp. 560-573.

Planche, Gustave. "Le Salon de 1852," REVUE DES DEUX MONDES (1852), pp. 669-695.

Proudhon, Pierre-Joseph. DU PRINCIPE DE L'ART ET DE SA DESTINATION SOCIALE. Paris: Garnier, 1865; reprinted by Gregg International Publishers, 1971.

Raskin, Richard. ELEMENTS OF PICTURE COMPOSITION. Århus: Århus University Press, 1986.

Redon, Odilon. A SOI-MÊME. JOURNAL 1867-1915. Paris: Floury, 1922.

Riat, Georges. GUSTAVE COURBET, PEINTRE. Paris: Floury, 1906.

Rosen, Charles and Henri Zerner. ROMANTICISM AND REALISM. THE MYTHOLOGY OF NINETEENTH CENTURY ART. London & Boston: Faber & Faber, 1984.

Rubin, James Henry. REALISM AND SOCIAL VISION

IN COURBET AND PROUDHON. Princeton: Princeton Univ. Press, 1980.

Schanne, Alexandre. SOUVENIRS DE SCHAUNARD. Paris: Charpentier, 1886.

Schapiro, Meyer. "Courbet and Popular Imagery: An Essay on Realism and Naïveté," JOURNAL OF THE WARBURG AND COURTAULD INSTITUTES 4 (1941), pp. 164-191.

Schlosser, G. "Intorno alla letture dei quadri," LA CRITICA 28 (Jan 1930), pp. 72-79.

Silvestre, Théophile. HISTOIRE DES ARTISTES VIVANTS. Paris: E. Blanchard, 1855.

Sørensen, Henrik Bruun. VERBAL OG VISUEL STRUKTUR. KINESISK KALLIGRAFI, POESI OG LAND-SKABSMALERI. Unpub. thesis. Art Dep't, Århus University, 1986.

Uspensky, Boris. A POETICS OF COMPOSITION. Berkeley: Univ. of California Press, 1973.

Vallès, Jules. LE CRI DU PEUPE. Edited by Lucien Scheler. Paris: EFR, 1953.

Weinberg, Bernard. FRENCH REALISM: THE CRITICAL REACTION. New York: Klaus Reprint, 1971; orig. pub. 1937.

Wölfflin, Heinrich. "Über das Rechts und Links im Bilde," in GEDANKEN SUR KUNSTGESCHICHTE. Basel: Benno Schwabe, 1941; pp. 82-90.

Zahar, Marcel. GUSTAVE COURBET. London: Longmans, Green, 1950.

Zola, Émile. "Proudhon et Courbet," in MES HAINES. Paris: Charpentier, 1928, pp. 21-34; orig. pub. 1865.

The catalogues of the following exhibitions were also consulted:

L'EXPOSITION DES OEUVRES DE GUSTAVE COURBET A L'ÉCOLE DES BEAUX-ARTS. May 1882.

L'EXPOSITION GUSTAVE COURBET AU PALAIS DES

BEAUX-ARTS (Petit Palais). May-June 1929.

GUSTAVE COURBET. ZURICH KUNSTHAUS. 15 Dec
- 31 March 1936.

EXPOSITION: COURBET DANS LES COLLECTIONS
PRIVÉES FRANCAISES, organisé au profit du
Musée Courbet. 5 May - 25 June 1966.

EXPOSITION COURBET AU GRAND PALAIS. 30 Sept
- 2 Jan 1978.

21 Die Steinklopfer, «Les Casseurs de pierres», 1849
Taf. XV

bez. G. Courbet. 259 × 158,5 Staatl. Gemäldegal. Dresden

Salon Paris 1850/51, Salon 1855, Sonderausstellung 1867 Nr. 5, Gedächtnis-
ausstellung 1882 Nr. 4; erworben 1904 an Versteigerung Binant Paris für staatliche
Gemäldegalerie Dresden; Staatliche Gemäldegalerie zu Dresden, Katalog der
modernen Galerie, 1930, Nr. 2522.

Catalogue entry, Zurich Kunsthaus exhibition of 1935/1936.
This is one of the rare entries in which the reported dimen-
sions of LES CASSEURS DE PIERRES are accurate.